YOU CAN
PAINT
WILDLIFE

Martin Knowelden

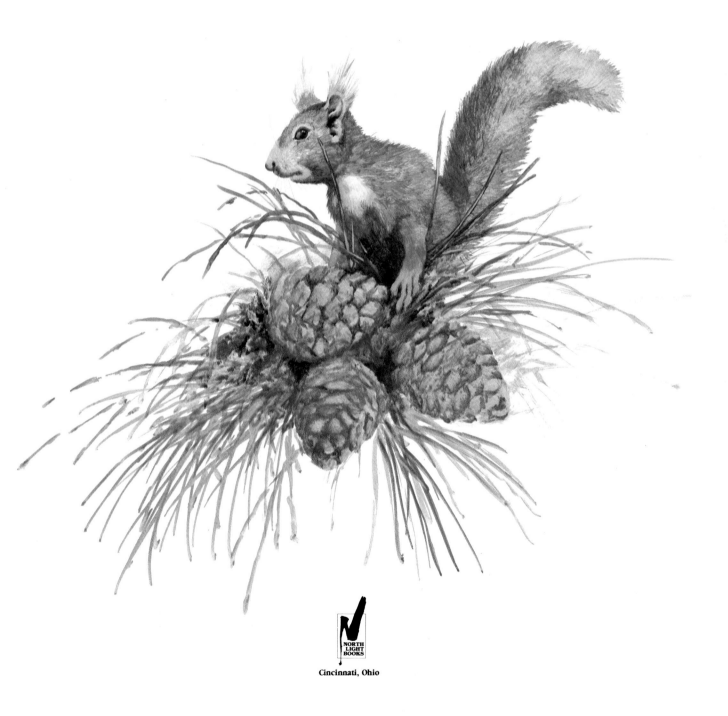

NORTH LIGHT BOOKS

Cincinnati, Ohio

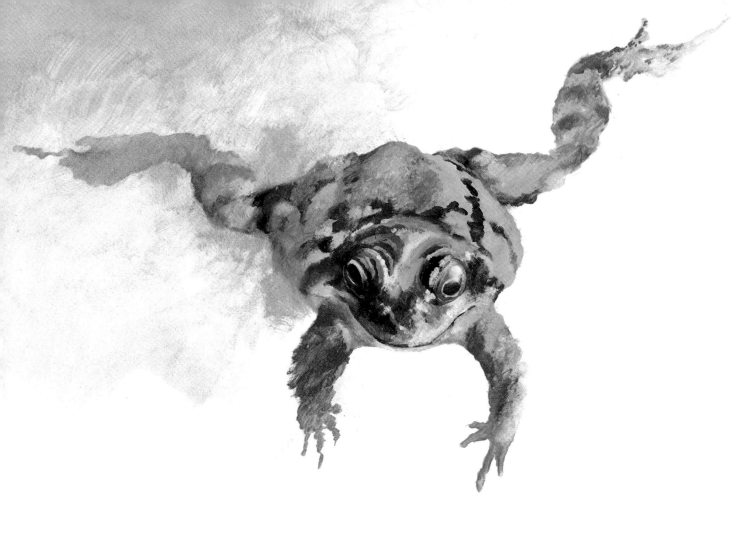

First published in 1985, new edition 1986
by William Collins Sons & Co., Ltd
London · Glasgow · Sydney
Auckland · Toronto · Johannesburg

First published in the United States in 1987
by North Light Books,
an imprint of F & W Publications, Inc.
1507 Dana Avenue, Cincinnati, Ohio 45207

© Ruan Martin Ltd 1985, 1986

Design and photography by Rupert Brown
Filmset by Media Conversion Limited
Colour reproduction by Positive Colour

ISBN 0–89134–219–2

Printed and bound in Italy
by New Interlitho SpA, Milan

CONTENTS

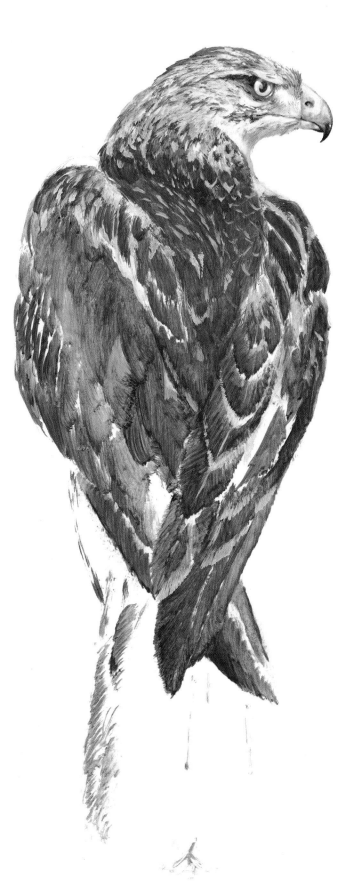

PORTRAIT OF AN ARTIST
MARTIN KNOWELDEN

Martin Knowelden was born in 1943 in Borehamwood, Hertfordshire, which was at that time still a rural community.

He cannot remember a time when he was not interested in drawing and painting wildlife – his mother still has a drawing of a mouse that he did when he was two. Animals featured in everything he did at primary school, even in a poster to advertise the school sports day that was set as a class project. As a junior schoolboy, Martin kept a menagerie of small creatures – newts, slow-worms, grass snakes, frogs, sticklebacks and mice – all caught locally. With school friends, some of whom came from neighbouring farms, he also learnt to hunt, often with ferrets, and to rear small birds of prey.

The young Knowelden's reputation as a 'mender of sick and lame birds' led to a succession of unusual house guests, the most notable being a jackdaw called Duncan which was hand-reared and lived free in the garden when not perching on Martin's head as he cycled to and from school.

It was at Borehamwood Grammar School that Martin was first introduced to pottery, carving, sculpture, the history of art and, in particular, the philosophy of Gustave Courbet. Later, in 1960, he was accepted at the Art School attached to Watford Technical College where he attained his National Diploma in Design (NDD).

After his first job with a local advertising agency he joined the TV Graphics department of the BBC. Two years later he returned to Borehamwood with a job at ATV (now Central Television) where he specialized in animation and programme graphics.

During these years Martin felt that both Borehamwood and he had lost touch with their rural beginnings, and in 1971 he formed a design and illustration partnership with designer Rupert Brown, setting up a studio on the banks of the River Stour in Suffolk. They undertook a wide range of work and the discipline of having to draw a hydraulic piston with an airbrush one day, followed by a cutaway of a medieval church the next, is something Martin considers the most useful experience for any artist.

His involvement with wildlife publications stemmed from his first one-man show of paintings and drawings. A publisher asked him to illustrate a book on rats, and this led to a wide variety of book illustration.

Martin draws a clear distinction between illustrating (for books, magazines and advertising) and painting. He has had exhibitions of paintings, drawings and bronzes in Europe and North America as well as in the UK, most recently at the Tryon gallery, London. He is currently working his way through a series of commissioned works in oil, with subjects including salmon fishing on the Wye, Jack Russell terriers hunting, and golden eagles in Wester Ross. These commissions are sandwiched between a series of paintings for six children's books and a book on hunting birds.

Martin now lives in the village of West Wratting, Cambridgeshire, with his wife and their two children. He grows all his own vegetables and greatly enjoys cooking and winemaking. He loves poetry and jazz and follows a wide variety of country sports. He breeds lurchers, keeps ferrets, and is an experienced falconer.

With scrupulous attention to detail Martin Knowelden offers in his wildlife paintings a very personal view which combines quite opposing elements. His treatment of animals in their natural habitat is sometimes hard and always unromantic, often revealing the harshness of life in the wild. The beauty of nature is always clearly present, however, and his work shows a sincere respect born out of his knowledge of this world. He quite obviously delights in the minutiae of his subjects, sometimes taking an almost microscopic view and delineating every pore and whisker. He has an unfailing eye for the unusual pose or situation, the incongruous prop and the intriguing composition, and includes in his paintings a wealth of subtle details, some of them decidedly tongue-in-cheek, to intrigue and puzzle the viewer. His work not only shows quite clearly his love, and his knowledge, of his subject, but also his love of paint. The play of light and shade, and the visual effects created by water are two recurring themes among many which demonstrate his genuine delight in capturing his quarry as a highly original image on paper or canvas.

Fig. 1 Martin Knowelden at work in his studio

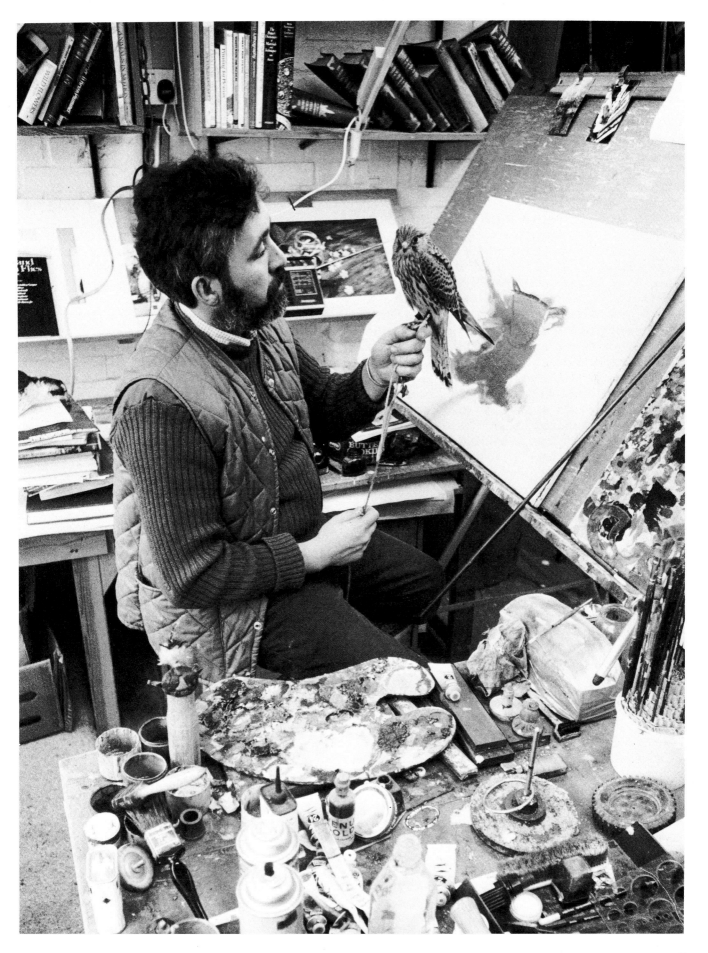

SELF-PORTRAIT

I cannot recall a time in my life when I was not drawing animals and birds. Growing up in a little Hertfordshire village which was beginning to expand with London's overspill, I, and my friends, resorted to the countryside at every opportunity for our recreation. We knew where to go to watch badgers and the ways of foxes. We tracked roebuck and rabbits and kept mice and slow-worms in our bedrooms. I helped the injured and sick wildlife of all kinds and made ready use of the opportunity it afforded for close and careful study. I thought the first kestrel I reared and trained the most exquisite thing in creation and I have re-expressed that feeling with all the wild creatures I have ever come close to.

Much of the time that I was not actively abroad in the countryside, I was at home with pencils and paints, trying to draw it, and the animals that lived in it. I was continually frustrated by an inability to achieve on paper the beauty and vitality of the creatures I saw in the wild and, eventually, I found myself studying the wildlife about me with the express purpose of drawing and painting it more perfectly. The number of the halt and the lame (mostly birds) I collected increased and a rather gruesome collection of bones, teeth, wings and claws began, to which I am still adding today. Although I did not appreciate it at the time, and simply studied and drew nature because it was an enjoyable preoccupation, I realize now the distinct correlation between observation and the quality of my drawings. It is true for all artists, whether professional or amateur, that the best of their work will be that which is most carefully and sympathetically observed.

I am still frustrated by the gulf between my paintings and the reality, but we learn from each picture done and, hopefully, improve as we learn. While I know that perfection is unobtainable, striving for it remains exciting and inspiring.

Not only does the desire to paint animals demand study and research, but the techniques of using paints and brushes, pencils and paper, watercolour and washes need practising and perfecting. There are so many permutations and possibilities to explore, and each one of us must find the most successful, the most suitable for himself. Developing a style and applying it to a particular subject like wildlife can be the most satisfying of achievements.

I must leave research and study for each of you to work out for yourself. Circumstances, opportunity and commitment will decide for you the amount you need to do, but the techniques and the tools, the order in which things are best done, and the rules and guidelines within which your work will be achieved are much the same for all of us, and I can describe those which I have found most useful in the hope that they form a base on which anyone can build a style of their own. Let us now consider a general approach to wildlife painting.

I have always delighted in the machinery of painting. The textures of watercolour paper, the shapes of palette knives and scrapers, the brilliance of a new canvas – the list goes on. Equipment becomes worn and polished with time and patinated by paint and spirit, and familiar tools fit the hand comfortably, becoming irreplaceable allies in the business of making pictures. Get to know your equipment in this way. Enjoy using your tools and practise until you no longer need to think about them but can work automatically, the brush or pencil becoming an extension of your hand. You can then give your whole

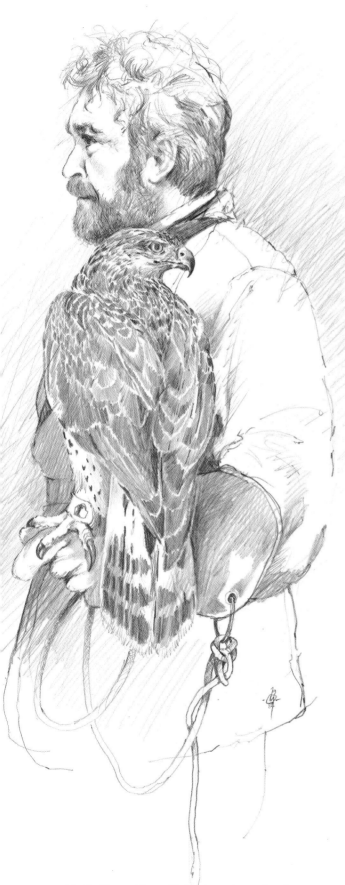

attention to the painting itself. The worth of a wildlife picture is in the quality the artist imparts to his subject which makes it not merely a representation of a creature in the wild, as is a photograph, but suggests the character and nature of that creature, and makes the viewer aware of the intangibles. A good picture shows, within its forms and composition, the grace, the power, the intelligence: abstracts which can never be delineated, yet are clearly there in the 'mood' of the piece. It should contain the essence of its subject, make a definitive statement. With these problems to ponder, as you work at your canvas, you do not want to have to worry about which way up the brush goes!

What I have tried to do in this book is describe, from my own experience, the practices involved in gathering together all the separate threads that finally make up the finished work. Starting with field notes and sketching, through studio drawings and studies, and finally composing and executing your picture, the procedures described here are all those I use myself and which resulted in all the pictures in this book.

Some techniques will come easily and others will most certainly not. Do not spend a lot of time, all at once, on those which prove difficult but, rather, work on them a little each time you sit down to paint. Remember that art is only 1 per cent inspiration and 99 per cent perspiration, so work – observation and practice – is the major requirement. Your skills will never develop without it. The more precision and careful study that you get into your preparations for a painting, the more depth you will impart to it. Finally, and above all, never let anything you do become a chore. There is no value whatsoever in a picture or a drawing that is finished reluctantly. Let all your work be, as mine is, the product of enjoyment and pleasure, and an abiding fascination in your subject.

Fig. 2 Martin Knowelden with his ferruginous hawk

WHY PAINT WILDLIFE?

The first images ever made by man were of wild animals. Captured in exquisite economy, using pigments on the smooth walls of caves, are scenes depicting our earliest ancestors and dotted with creatures recognizable still as zebra, buffalo, giraffe and all kinds of antelope. Men with spears, bows and clubs, accompanied by curly-tailed dogs, weave in and out of these panoramic murals. Why these images were created we can never know with certainty, yet, even before man had formalized his gods, he was recording a relationship with the wild creatures of his environment in colour and line. Since these earliest records, man's attitudes to animals have been complex and contradictory. Some suggest that these early paintings were inspired by a mystical belief that the capture of an animal's image was analogous to the capture of the beast itself. The qualities of wild creatures – the cat, the hawk, the jackal, the ram, the scarab beetle and the serpent – were apportioned to the deities of ancient Egypt, and their depiction as man-bodied and animal-headed reflects the complex interaction of man and nature as perceived by the artists and sculptors of that long-dead civilization.

Many primitive societies carved and painted the symbols of their worship in animal forms, and this 'totemism' is evident in the wealth of animal representation seen all around us today. The beasts of the primitive totem makers have their modern-day counterparts in the lion at Britannia's side and the American eagle, both symbols of strength, reliability and courage we all recognize. Behind them is a vast array of creatures, each with its special qualities, symbolizing all aspects of our own lives and embodying ideals that we might all aspire to. The symbols of trade and industry featuring animals are legion and there are countless examples ranging from these to the tattooist's art, with every conceivable sphere in between.

The Victorians' sentimentality saw in animal behaviour lessons and moral pointers for us all to heed; Aesop had shown this with considerable humour, and much more vigour, centuries earlier. Yet Gustave Courbet, the French painter who became the father of modern art, derived from his hunter's knowledge of wildlife, combined with his careful study of animal life as an artist, a clearer understanding of his own place in the great scheme of creation.

Whatever the reasons for attempting the painting of wildlife (and I suppose there are as many reasons as there are people wishing to try it), let us begin with the simplest of motivations, the easiest to understand: admiration. For example, one sees a simple admiration for such creatures, so at one with their environment, in the cave paintings at Lascaux, and I look for no deeper or more obscure reason for their creation. Whilst they may be much more, they are certainly a celebration of superior strength and speed; skills in coping with hunger, drought and weather; abilities for providing shelter and food for their young; and, above all, freedom under the sky. Wild animals have always fascinated and intrigued us and, for some of us, this fascination has manifested itself in a desire to capture, as did our ancestors, some essence, some definitive quality stated in colour and line. The act of painting a mammal, bird or fish in a way which sums up some fundamental quality of character is, in itself, an expression of admiration, and if the image so made imparts that feeling to those who see it after, the work is properly one of art.

At its very best, animal art makes a profound statement about man's relationship to the rest of creation. At its most humble, the artist simply uses the many beautiful colours and the myriad remarkable forms that nature provides as the basis, the foundation, on which rests his own desire to create.

Whatever the motivation, taking a sketchbook and field glasses into the countryside and collecting material for use in the studio, as well as the general study of nature with the painted image in mind, is an absorbing and satisfying pastime. With sufficient practice to achieve a commercial standard and with an understanding of the demand from so many areas for animal and natural-history imagery, there is no reason why your hobby should not also be a source of income.

Backgrounds

The way we see wildlife, as a general rule, is in brief, sudden glimpses. Human eyes are so placed that we have a field of focused vision of about 17 degrees and we scan our surroundings either by moving the eyes themselves or by utilizing the articulation of the head. When we suddenly catch sight of a wild creature, we tend to fix on the animal (and on its eyes in particular if possible), and everything outside that 17-degree field is perceived as blurred vision, unfocused and indistinct. The animal becomes a vivid, sharply defined object on a vague, soft background, like a sparkling gemstone on a velvet tray.

Backgrounds, then, seem to be seen as impressions and, for the purposes of impact in your picture, they

are, with some notable exceptions, best kept less than sharp. Aim for bold colour and strong lines that lead the eye to the focal point of the picture plane, without distracting it with unnecessary detail. An equal degree of finish over the whole painting gives the eye no 'high point' to fix on, no contrast or conflict to resolve, and consequently the picture lacks power.

I always start an oil painting by deciding on an overall general colour, usually dark green or dark brown, and laying it over the whole picture area, whether paper, canvas or board, with a wide flat brush, say a Dalon D.88 $\frac{1}{2}$ inch (or 1 inch for larger pictures). I let the natural texture that the brush imparts form the basis for the background. Grass and rock require quite different surface textures, yet I form both by the same technique – rubbing or scraping away the dark base colour to reveal the pale surface colour beneath. Experiment with this 'drawing in reverse' technique on scraps of paper or canvas; it can be very effective. I begin painting highlights into this base, developing and detailing the most the areas nearest the subject of the picture. I then mix a very dark colour (enough to last, for it will be needed for shading over the whole work), which is sympathetic with the base colour, perhaps the same dark green or brown I began with, and add it as shadow, rounding out and giving depth to the forms delineated earlier.

Backgrounds are as varied as subjects and need a varied approach. Some subjects might require no more than a colour wash or 'tint' to offset the focus, while another might well demand a complex tracery of leaves, flowers, branches and grass. There are no hard and fast rules and you must decide for yourself just how far, or in what direction, you must go according to the particular piece you wish to work on, or your particular style. There are one or two basic pointers, however, well worth bearing in mind. The background of a painting functions as the setting for a jewel; the gold surround supporting a diamond. It must enhance and underline the beauty of the centre of focus; it must frame and isolate; it should lend importance, making the viewer aware that the subject deserves special attention.

Once you have a clear mental picture of how you wish your finished piece to appear, you should establish just how 'finished', how detailed and polished, your subject will turn out. The background should then be worked backwards, as it were, from this point, never competing with the subject by equalling its 'finish', yet complementing and encouraging it, making the total of the work more than the sum of the parts. Remember that cold colours – blues, greens and tints based on the blue end of the spectrum – recede; they seem to go back into the canvas as you look at it. Warm colours project; reds and browns and the tints from the spectrum's yellow end seem to come towards you as you view the canvas. Use this optical effect for your own ends: a fox hidden in the grass would appear much more hidden in brown or yellow grass than in spring grass, lush and green. The colour of the fox, being a warm colour, projects out of the canvas and the colour of the grass can either throw it into sharp relief (if it is green and therefore recedes) or can complement and soften the subject (if it is yellow or brown and projects with the subject).

Shadow can be used to increase depth, anchor an object to a surface, or describe or reinforce the form of a subject by the line it takes as it falls across your scene. It can also be used to emphasize the texture of a background and is, of course, a simple way of justifying a dark or black background for anything pale or white which needs a clearly defined edge.

WHAT EQUIPMENT DO YOU NEED?

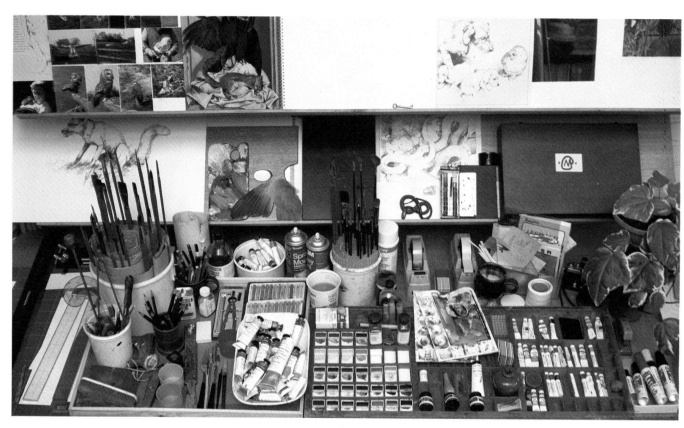

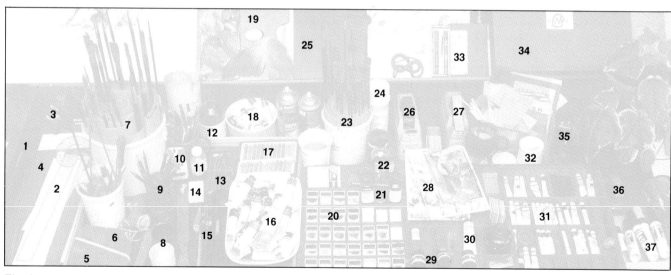

Fig. 3

Key to materials

1	Metre straightedge	8	Dipping pots	18	Gouache paints	28	Watercolour palettes
2	Perspex rule	9	Pencils	19	Oil palettes	29	Drawing inks
3	Mount cutter	10	Lighter fuel	20	Watercolour pans	30	Gel retarder
4	Cutting mat	11	Masking fluid	21	Varnishes	31	Watercolour tube paints
5	Desk brush	12	Linseed oil	22	Rotring inks	32	Paint wells
6	Emery cloth	13	Rotring compass	23	Watercolour brushes	33	Portable watercolour box
7	Brushes (Dalon) for oils	14	Putty rubber	24	Aerosol fixative	34	Portable oil painting set
		15	Palette knives	25	Sketchbook	35	35mm SLR camera
		16	Oil paints	26	Sellotape	36	Stapler
		17	Pastels	27	Draughting tape	37	Felt tip pens

Modern paints – oils, watercolour and gouache – are of superb quality, and while they may appear expensive as you survey the price list, a little goes a long way and they are, with proper use, very good value. A reputable supplier offers a huge range of pigments in several sizes and qualities, catering for amateur, student and professional artists.

Oils

Start with a comprehensive range of basic colours and wait until you have practised your palette for a while before you buy any of the more exotic colours. I would suggest you start with the primaries – blue, yellow and red – in two forms, 'hard' and 'soft'. I would describe Prussian Blue, Golden Yellow and Cadmium Scarlet as 'soft' primaries. Mixed with Zinc White (a 'transparent' white), they produce tints which are mellow and organic. Cerulean, Lemon Yellow and Rose Doré are 'hard' primaries. Derived, as most 'hard' colours are, from mineral or chemical pigments, they throw tints which are hard, clean and brilliant. These six colours should form the basic colour box to satisfy any requirement; simply add to these black and white.

It is as well here to describe the three whites. Flake White is a lead-based paint and, consequently, is dangerous if misused. It matures with a warm, amber tinge and is reasonably permanent, giving mellow tints and a 'glow' to work as it ages. It covers well used neat. (Permanence is the ability a colour has to remain as painted. Some violets and maroons change their colour very rapidly if left exposed to light; such colours are the opposite of permanent, i.e. fugitive.) Titanium White is derived from a mineral pigment and is brilliant and hard, giving off a lot of light. It, too, is permanent, although not to the same degree as Flake, and mixes a clean, sharp tint. Zinc White is produced with zinc oxide and is the least solid of the three. It is just as permanent as the others but imparts a translucent quality to its tints and can be used for building up layers of colour. Choose whichever white you feel most suitable (or buy one of each) and, with Lamp Black, your basic colour box is complete. I would, however, suggest that you add the earth colours – Vandyke Brown, Raw Sienna, and Yellow Ochre – and a good base green with very high permanence is Terre Verte.

You will also need a spirit in order to dilute your colour and an oil for your basic medium. Use turpentine for your diluent, and for your medium, linseed oil is unbeatable. For outdoor work or sketching, Gel Medium or Alkyd Medium mixed with oil paints are really excellent and dry in half the time oils take. Copal Varnish is a useful addition to your equipment, too. Thinned with turps, it can be used to varnish a finished work and, mixed with turps and linseed oil, it forms a beautifully smooth medium with oil colour, allowing easier brushing and a faster rate of drying.

Watercolours and gouache

The difference between watercolour and gouache is in the nature of the paint itself. Watercolour gives a clean and transparent tint which is used as a thin wash on damped paper. The colour of the paper shows through and gives watercolour its luminous or glowing quality. Gouache is an opaque or solid pigment which is thinned with water and used on textured card or board, much as oil paint.

Brushes

Brushes, for me, are no longer the problem they were. The synthetic fibre used for many brushes is incredibly fine and ideal for oils; I use, now, nothing else. Even in the smallest sizes they are, in my opinion, the equal of any natural-hair brush and, what is more, they stand up even to my careless and heavy-handed treatment. (They come back to new with an occasional application of paint-stripper!) I have brushes from the whole range and I will pass on a useful tip here: get into the routine of buying one or two brushes each week and work your brushes in over a period. I try to avoid using a pot of brushes until they all need retiring and then having to start again with a brand-new set. It is also a painless way of renewing your most important item of equipment.

There is, of course, a great range of brushes and you must try several before you find the one ideally suited to your needs. I have found the perfect brush, for myself and look no further – you will find your own in time.

Watercolour, however, can only be worked with brushes made of natural hair, and very fine hair at that. Sable is incredibly strong and springy, considering the fine nature of the hair, and comes from a mink-like creature from Eastern Europe and China. Sable is extremely expensive and works quite beautifully, and a watercolour brush, carefully cleaned and shaped after use, will last for years. The less commonly used sizes and the big ones used for washes of flat colour are made in less expensive mixtures of hair without any loss of quality. I use pure sable, ox and sable mix, and some squirrel. Watercolours are notoriously difficult to control with inferior brushes, so make life easy on yourself and buy one or two top-quality sables.

Always clean your brushes thoroughly with a clean rag and whatever solvent is relevant: turpentine with oils, water with gouache or watercolour. While still damp, smooth and shape the brush, then stand it, bristles upward, to dry out naturally. A coil of corrugated cardboard held inside an old coffee tin

makes an excellent brush stand, the handles of the brushes being pushed into the corrugations.

Pencils

Pencils, although the most commonplace of all an artist's tools, cause confusion and discontent. A pencil is a wooden sleeve surrounding a core of graphite mixed with clay. The wooden surround is cut away with a knife to expose the graphite core, which gives a black line. The more clay you mix with your graphite, the harder the core (or 'lead') and, consequently, the finer and paler the drawn line. The less clay in the mixture, the softer and blacker the line; simple, really. The hardness of a pencil is graded in degrees of H, the softness in degrees of B; an HB pencil is the average of the two. Buy hexagonal (easier on the hand) drawing pencils of the best quality only (buy cheaply, buy twice), in degrees HB, 2B and 6B. Shape your pencil point with a very sharp knife or one-sided razor blade to a long narrow point, the exposed lead being about a third of the overall sharpened tip. This allows you to use the sides of the pencil lead as well as the point. You will find a Black Beauty (an extra-fat 4B) very useful for filling in, and I prefer charcoal pencils to the traditional charcoal sticks. Kneaded erasers are useful for more than just erasing. They can be used as one would use white to draw into a sketch, or as a burnisher to smooth and soften pencil lines. All pencil, conté (a densely black wax crayon) or charcoal work needs fixing when finished to prevent smudging and you can choose a clear plastic varnish in an aerosol can or in a bottle with the old blow-pipe system.

Pens

Pens are a matter of personal preference. I do not like plastic pen holders as they are too short and too light (and plastic!), so I make bamboo holders of my own. I like the weight and feel of the wood and bamboo is non-tapering. I use sections of bamboo 10 mm ($\frac{3}{8}$ in) in diameter and 165 mm ($6\frac{1}{2}$ in) long. Gillott nibs are unbeatable and practice will indicate which grade suits you best.

Useful extras

You will find a number of odd tools very useful as you continue painting. A small, flexible palette knife, used to bring oil colours in from the edge of the palette to the centre for mixing, will keep colours clean and separate. A few scrapers for working into wet paint can either be made or found about the house. I have some sharpened bamboo, some old paintbrush handles with glued-in tips of bone and antler, and a variety of recycled knitting needles, chopsticks and screwdrivers.

Broken combs make lovely patterns drawn across the canvas, and old toothbrushes make good stipplers. All I can say about these gadgets is that you will know one when you see it.

A mahl-stick (the traditional artist's stick with a padded end) will keep your sleeves off your canvas when you work, will give you a straight edge for ruling brush lines or establishing horizontals and verticals, and will support your wrist for very small detail or precision work. To make one, use a metre (1 yd) length of 7 mm ($\frac{1}{4}$ in) copper tubing and bind on a chamois-leather pad at one end. Other useful aids are a pair of dividers, which will save you time and effort when transferring proportions on to the canvas, and, of course, compasses – very few people can draw a perfect circle freehand.

Save the plastic caps from aerosol cans; they make perfect dippers and you can discard any that become too encrusted. Rags are essential and must be free of any fluff which might transfer to your paint surface.

Painting surfaces

And now the problem of what to paint on. Water-colour papers are many and varied, giving more or less surface, greater or lesser strength, different degrees of absorption, and a wide range of textures. The prices vary considerably according to the structure of the material (paper is made from many different fibre types, rag being one of the best, wood pulp one of the coarsest) and the method of production (some are still hand-made). Once again the rule must be to try them and find out for yourself which is most suitable for your own purposes. An 18 × 24 inch pad is probably the easiest way to buy it.

For oils you have a choice of textures from rough to smooth, in canvas either ready-mounted on a stretcher or off the roll. Rough-textured is probably best left until you are well practised. Gesso is a very fine plaster and size mixture, resembling sour cream, which, used as a primer on your canvas, produces a surface as fine and smooth as paper. You can buy canvas, ready-primed, mounted on thick card squares, which are especially handy for outdoors or sketching. Gesso can also be used to prime hardboard or heavy cardboard, both popular and economical surfaces and both good for wildlife subjects because they are smooth and texture-free. There are many papers specially prepared for oil-paint sketching and you should buy a good block, say thirty sheets, 18 × 24 inch size, preferably with a waterproof jacket.

A drawing board is an excellent basic work-top and is easily carried with your paper in a sketching bag. It can be propped up on a table or used with an easel for painting indoors. Buy a wooden board, about 65 × 45 cm ($25\frac{1}{2}$ × $17\frac{3}{4}$ in). Easels come in a wide range of types and prices and you should choose the best you

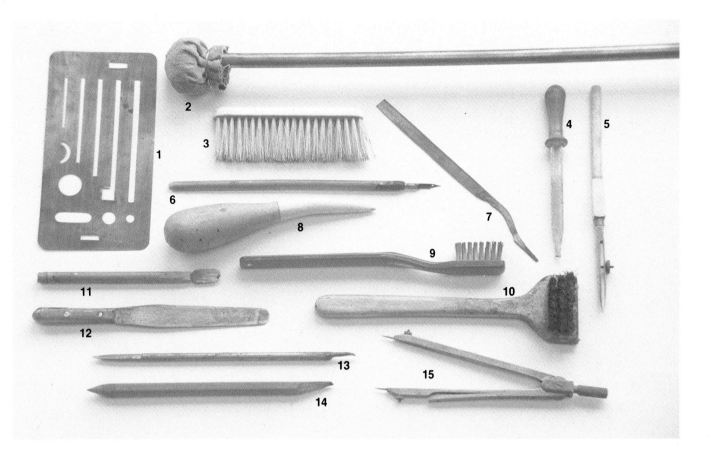

Fig. 4

1 Masking template	6 Cane-handled mapping pen	13 Brass scraper
2 Mahl-stick	7 Saw-toothed scraper	14 Bamboo scraper
3 Small cleaning brush	8 Burnisher	15 Dividers
4 Dropper	9 & 10 Brush stipplers	
5 Ruling pen	11 & 12 Mini palette knives	

can afford for the space you have available. If you want an outdoor one, a lightweight wooden sketching easel with collapsible legs and carrying handle is ideal. For indoors, something more solid is better.

All this is still only the basic equipment, and one of the great pleasures of painting is the accumulation of materials and tools. You will want, as time goes by, much which I have not mentioned here, and a good relationship with your local art shop will prove invaluable. There are doubtless many items I would never think of using, which you will come to regard as irreplaceable in your paintbox.

Finally, take care when storing pictures. Watercolours should be kept out of the light, in a drawer, say, laid flat and protected by a sheet of tissue. Oils need to be stored upright and, when dry (sometimes this can take six months), varnished with a proprietary picture varnish of the brush-on or aerosol type.

TECHNIQUES

An artist's style – that which makes one person's work quite distinct from any other's – comes about because of the unique way in which each individual uses his or her tools. Van Gogh's short, stabbing, flat brush strokes, flowing in coils, or Seurat's tiny points of colour, mixing on the canvas, are both immediately recognizable. You must experiment and practise with the tools at your disposal and find out the range and versatility of each one; what each piece of equipment can do for you. I have a small watercolour box which I find invaluable for field notes and yet contains only eighteen quarter pans and one No. 4 round-end sable. These, I soon discovered, are sufficient for all the jobs I need doing out-of-doors, from colour washes to fine pen lines. A 5mm HB automatic pencil completes the kit, and I keep them all in a sketching satchel hanging, always ready, by the studio door.

You have only to look through an art supplier's catalogue to realize the vast range of tools and materials at your disposal. Experiment with as much as you can and try to reduce your requirements to a good, comprehensive, basic toolbox. Discover what serves your needs best and concentrate your practice on those techniques exclusively until they are second nature. When you are thoroughly conversant with your medium, like a musician who has mastered his scales, you can go on to improvise constructively.

The main tools of the artist are pencils and brushes, and the effects they can produce deserve some study. It is worth remembering that, artist or bricklayer, you should let the tools do the work for you.

Brush effects

In the case of brushes, practice will soon show you that one good-quality sable will give you a wide 'vocabulary'; a great range of textures and lines. Fill your brush with black watercolour wash and draw it across the paper from left to right at varying speeds. If it drips or splutters or in any way behaves on its own, take note how and why. It may well be of use. As the brush dries, gently splay out the fibres and see what marks you can achieve now. Lay the brush flat on the paper and roll it along. Discover the effects that you can get with the point, side, and flat of the brush, using it wet and dry alternately. Practise guiding your brush in as many different ways as you can and build up a set of practice sheets for reference. When you feel you have done enough with watercolour, begin again with oil paint, using turpentine substitute to thin your pigment to a wash.

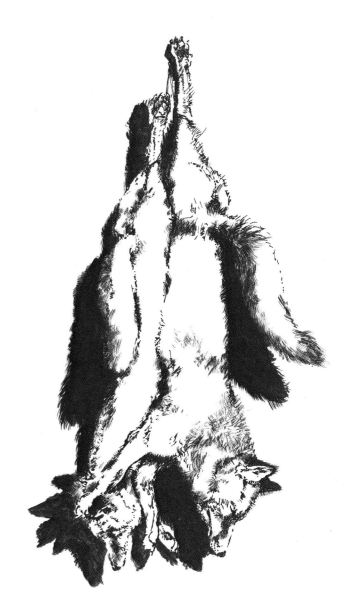

Fig. 5 Fox and vixen: rendering the fur effect with a brush

Any new equipment requires practice to get the best results. Try another simple exercise: take a 12 × 18 inch sheet of watercolour paper and pencil in a grid, five spaces by five, giving you twenty-five squares. Take your new brush (or pen or pencil) and try to achieve a different texture in each square. A brush can be pushed as well as drawn across the page, and the tips of the bristles will give you stippling while the flat side gives you dabs of colour. Try your brush full of paint, then

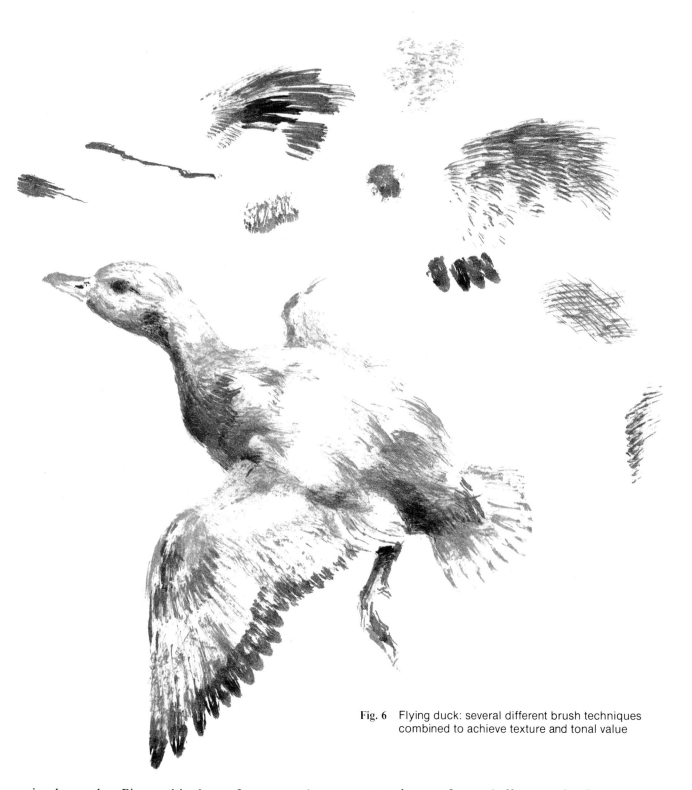

Fig. 6 Flying duck: several different brush techniques combined to achieve texture and tonal value

again almost dry. Pin up this sheet of textures where you can refer to it when you come to your finished work.

Without practice you will struggle to achieve effects that with the right tools used in the right way you will find simple and quick; anything in your painting that is laborious or has been tedious to achieve will look like it. Wildlife, more than any other subject, needs to be spontaneous and full of life.

The watercolour sketch of the duck **(fig. 6)** illus-trates the use of several effects coming from one brush. The textures of plumage, beak, leg and eye were all created using basically single-stroke work. The foxes **(fig. 5)**, sketched after a farmer's shoot, were done with pen and ink, and I could well have spent hours rendering the fur had I tried to carry on with the pen. As it was, I used my brush again and rendered the fur effect in a few seconds. It also gives a far more convincing portrayal of the texture of fox-fur than any other method might have produced.

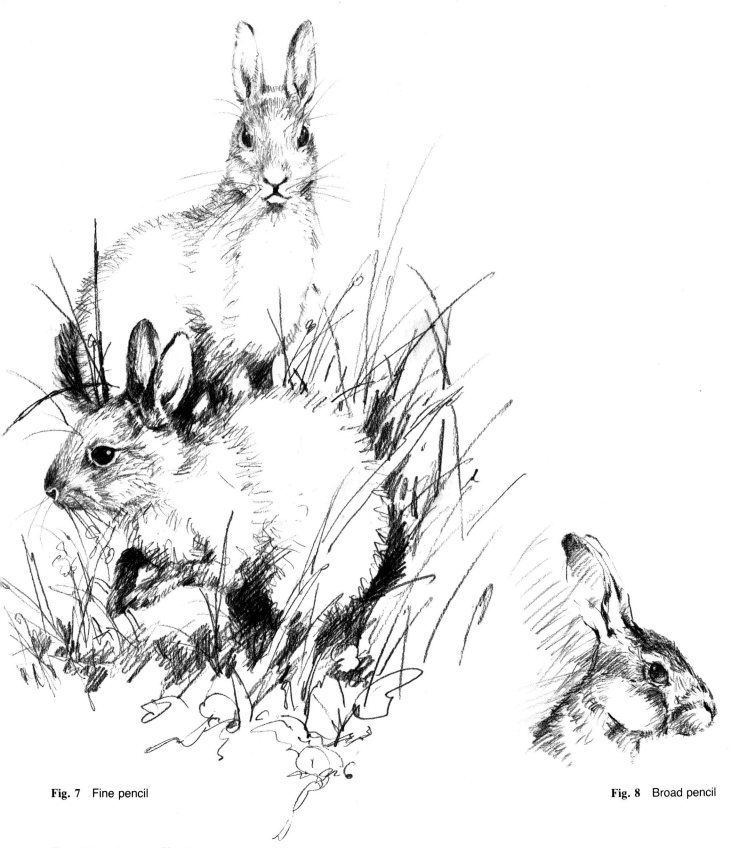

Fig. 7 Fine pencil

Fig. 8 Broad pencil

Pencil and pen effects

Fine pencil The beauty of a fine pencil is in its ability to achieve texture and tone by a series of criss-cross lines or 'hatching'. For wildlife studies, this technique gives marvellous precision for detail work. Keep a fine point on your pencil and a light touch, and build up density, as you would with watercolour, with a series of layers.

Broad pencil Strong, bold lines and areas of tone or shadow can be 'hacked' with a broad, soft pencil without wasting a lot of time. Use a long, tapering point and get your pencil to do the work by using the side of the lead as well as the point. Use your fingers to rub and shape areas of shadow. Aim to capture the essence of your subject in a few quick lines.

16

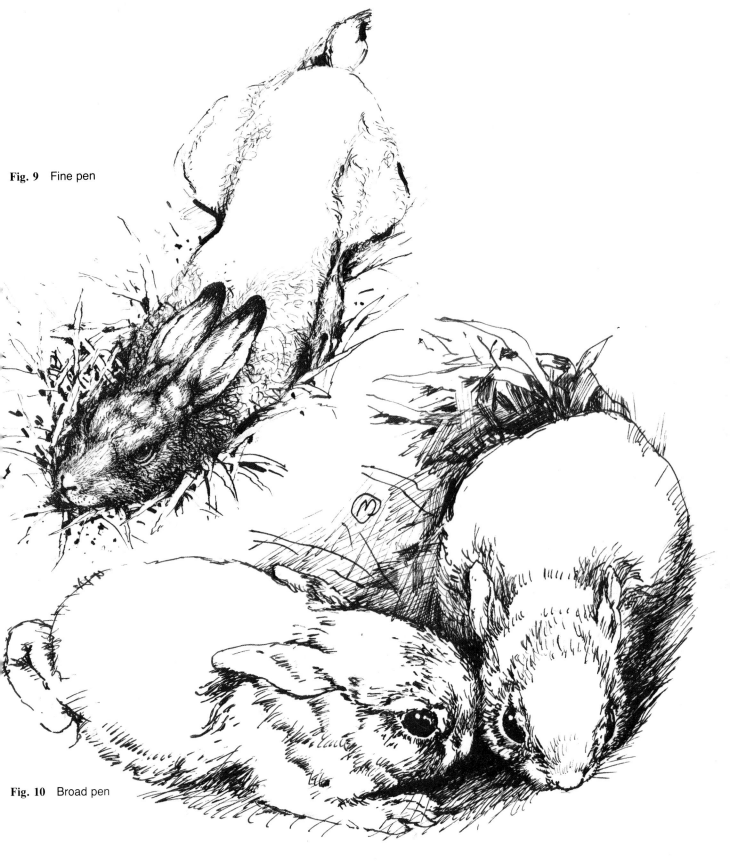

Fig. 9 Fine pen

Fig. 10 Broad pen

Fine pen A fine pen is an unforgiving tool and demands practice to achieve worthwhile results. It is rarely used in my studio, but it gives an effect, like steel engraving, which is impossible to get any other way. The prime requirement for fine pen work is patience!

Broad pen Any amount of finish is possible with a big nib, from loose, sketchy impressionism to highly finished realism. Use your pen freely and quickly, seeing what effects the pen itself can make. Develop and adapt those which suit your style best. Doodling is great practice.

17

ANATOMY

Just as you must practise a range of basic techniques to get the results you want from your equipment, so you must familiarize yourself with your subjects to achieve any worthwhile images. All creatures, in their construction, obey certain strict rules. Movement and form are limited by these underlying rules and the artist must learn what goes on under the skin of the creatures he wishes to paint if he is to impart any authority to his work, or bring any fuller understanding of his subject to the viewer.

Under the general heading 'anatomy', the artist should remember four elements which apply to fish, birds and mammals equally: frame, form, texture and colour. Let us look at each in turn.

Frame: the rigid skeleton which dictates the basic shape of the creature. Bones cannot stretch or bend so they give each animal a set of related measurements which are unchanging. Articulation is the movement of bones, one with another, at the joints. The remarkable complexity of bones in a bird's neck means it can articulate its head through 180 degrees and look directly backwards. The much poorer articulation of a toad's head means it must move its whole body to face in a given direction.

Form: the muscles which clothe the skeleton and give the animal a range of postures. There are certain poses characteristic of each specific animal, and the

Fig. 11 The underlying structure of a squirrel's frame (tail not shown)

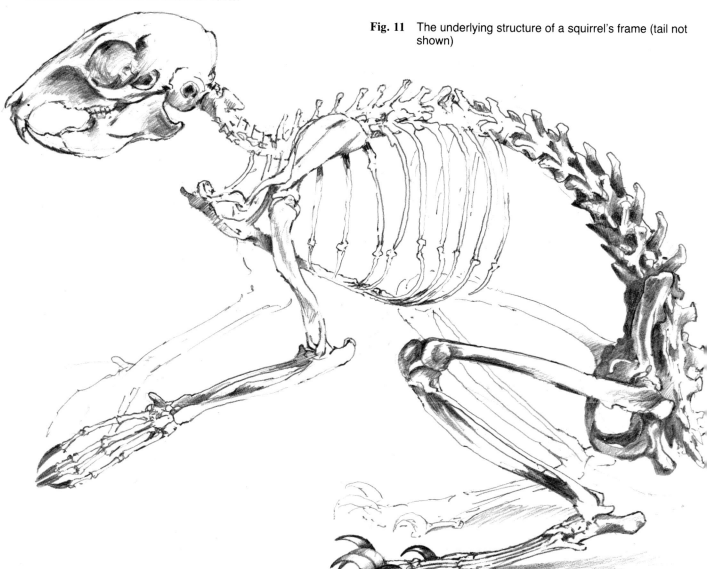

MAMMALS

changing shape of muscle describes activity or rest, anger or calm.

Texture: the 'feel' of the surface of your subject. Smooth fur, shaggy fur, smooth scales, rough prickles, wetness or dryness.

Colour: the artist must observe closely the colour of his subject. A white cat sitting in sunshine will carry gold and orange highlights and warm grey shading. In artificial light its colour will be hard white in illumination and a clean middle blue in shadow. Your subjects not only carry their intrinsic colour and pattern but take on the tints of reflected light from their surroundings.

The only way you will acquire the knowledge you need in the above categories is by studying, and a pencil and sketchbook should never be far away from you in case an opportunity for making notes or drawings comes along. If you have a dog or a cat, look carefully at how it is put together and how its tail, legs, ears, etc., join on to the trunk. Fish or fowl in the kitchen will give you a wealth of information as well as a good dinner!

Movement in an animal derives from its structure and should be most carefully portrayed. Until the camera caught horses in mid-gallop, it was normal for them to be painted with the forequarters stretched in front and the hindquarters stretched out at the back. This was later found to be quite incorrect. Stubbs had already realized from his very close study of anatomy (some of his drawings of horse musculature are still used in veterinary text-books, so accurate and complete are they) that horses, when galloping, move their legs in a rotary cycle which never allowed for the 'stretched' position conventionally painted. When Edouard Muybridge set up his long line of cameras to analyse movement more scientifically, his pictures of a galloping horse proved Stubbs to be right.

Perspective may shorten or stretch form, but must always convince the viewer that it is his viewpoint which causes these distortions and not the drawing of the subject itself which is inaccurate or wrong.

In conclusion, we have four main categories, plus movement and perspective which stem from them, to give us dependable guidelines when drawing or painting animals, and these are considered over the following twelve pages. Actual measurements are not essential, but relative sizes – that is, the proportions of one creature compared with another, or the size or weight of an animal's limbs in context with its body – are important. You must use your eyes!

The skeleton of the squirrel (**fig. 11**) is dominated by the backbone, which is massively built and exceptionally supple. It extends into the bones of the tail at the pelvis, and attaches to the skull at the atlas and axis vertebrae. This line from skull to tail tip describes the essential profile of the creature. The heavy bones of the hind legs articulate in such a way as to fold the legs away under the creature's body, leaving only the feet and toes showing. As the body moves there are key points where bones make changes on the skin surface. Knees, elbows, jaw-line, all the heavy black lines shown in **fig. 12**, are pressure points and dictate form for any given attitude the squirrel adopts. Drawing these charming animals in your local park will give you a wealth of positions and attitudes, but you will need a comprehensive knowledge of the underlying structures when you come to translate your sketches into a finished piece of work, where you may well wish to adapt and alter your preliminary drawings to get your composition exactly as you want it. The skeleton of the squirrel is fairly typical of the skeletons of most small mammals, so a working knowledge of it can be applied to other similar creatures.

Finally, if you reduce the skeleton to its major parts you will see that the head and ribcage can be drawn as two spheres, one (the head) two-thirds the size of the other. A connecting line runs from the head, over the top of the ribs, and on to the tail tip. Halfway down this line the hind legs can be drawn in as an S-shaped line and the fore legs are placed at the front end of the ribs. Drawing the long line of the backbone and tail will give you the posture: compressed for a crouching animal, flattened for the beast in flight, etc. The limbs and the bulk of the torso will always fit into place once this line has been established and, using field observation and your notebook, you will be able to place your subject in exactly the attitude you want.

Fig. 12 The points of mobility on the animal's surface

STUDYING YOUR SUBJECT

For anyone who walks regularly in the countryside, or in a local park, specimens from nature will often be found. Dead birds or mammals may seem unsavoury, but quick inspection (for the not too squeamish) will decide you as to their suitability for bringing back to your work-place for closer study. Natural specimens are invaluable for the wealth of detail they allow you to commit to paper. The process of drawing from life (or death in this case) has two prime functions: as you work carefully with pencil and paper, you are not only building your library of reference with an accumulating collection of drawings, you are fixing in your mind the detail which, taken as a whole, gives authenticity to your work. There is a third function also, less important perhaps but still contributing to the quality of your painting. As you move your specimen bird or mammal about, changing its position for sketching, you will begin to get a feeling of the creature's articulation: the way it moves. How far, for example, can a bird's wing stretch forward and then back? How do the toes of a mouse move from being wide-spread to closed? All these details – all this knowledge – are there in the background whenever you come to apply paint to paper or canvas.

As you get to know your subjects, you can set them up with pins or blocks in more lifelike positions. You will have to 'cheat' your drawing in many small ways so as to completely reinvest your subject with life. Incidentally, one word of warning about using an eraser. If you make a mistake and rub it out, you will almost certainly make the same mistake again. Leave all the lines in until you get the right one, then, if you must, erase carefully, reinforcing the correct line with pencil as you go. I prefer drawings with all the lines the artist makes intact. Augustus John's study of a whippet, with its vague profile made up of many exploratory lines, becomes not only a perfect work of reference, but so precisely captures the nervous tension of the dog as to elevate it to a true work of art.

Try pushing your model (I shall refer to whatever little corpses you may have collected as 'models' from now on) into a position where you have one side stretched and one side closed. In the case of the rat shown here, I positioned it in a typical pose using props and blocks and began a series of detailed drawings around one good general view of the complete animal. Sketch in with bold, simple lines the major areas of bulk in your model. Connect these with a profile (the line that you would draw if you were making a silhouette) which suggests tension. The hard, straight lines connecting curves suggest taut muscle, while depressed curves indicate slack. Now study your model for different textures. The sleek fur of the rat's back is shiny smooth, but the fluffy fur on the underparts appears dusty and diffused. Wet fur is spikey. With a brush, draw in a little of each. Now take a look at the detail of the rat's head. See how the fur there becomes finer in places until it disappears smoothly into the skin; see where follicles (the points on the skin where whiskers sprout) are placed. Study your own model and carefully draw in, with brush strokes which follow the direction of the hair, the contours around the small muscles of the face. These are crucial to animal painting as they give your subject facial expression. Make a special detail of the eye, opened wide, and note colour and size, for accuracy. Make details of the feet and fingers, and all the time you work, look at your model and then at your drawing for short, alternating periods. Draw a little, check a little, draw again, check again. Do not concentrate on one small area for too long at once, but jump from tail to ear, foot to eye, overall mass to detail of fingernail. Break off every few minutes, relax your concentration and look at something fresh for a few moments. Then go back to your drawing and your model with a new eye, and look at both for a while before starting to draw again. A discipline will develop which will be invaluable as a base for all your painting, as it has been for artists of all kinds since painting began. When you have studied your model and, with pencil, pen or brush, captured all its secrets on paper, change its position and start again. You cannot do enough, and after thirty years of painting wildlife, I still cannot do enough drawing from life.

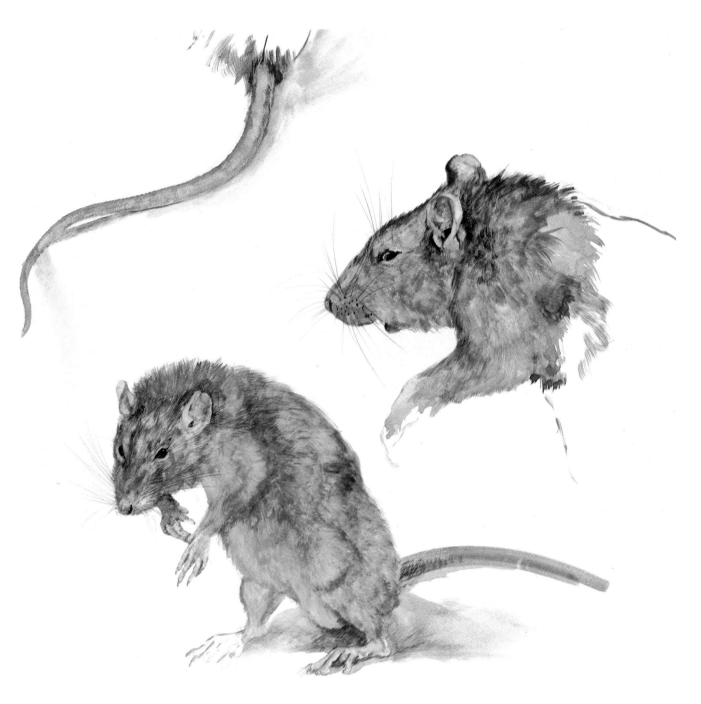

Fig. 13 Doe rat: the approach, in watercolour, to a studio specimen set up on blocks

FORM, PROPORTION AND PATTERN

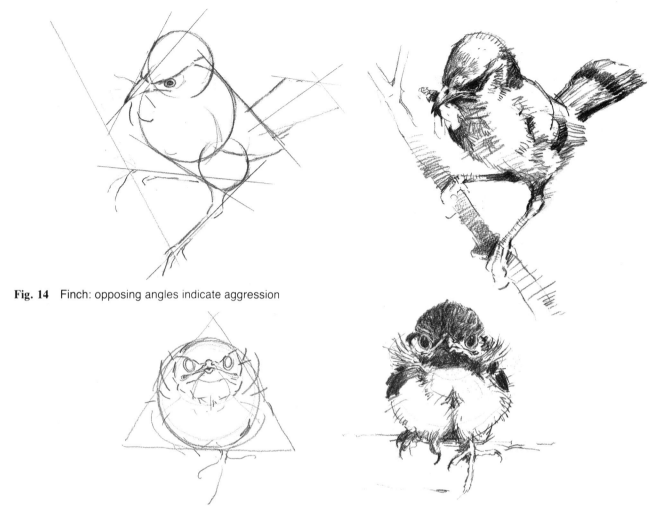

Fig. 14 Finch: opposing angles indicate aggression

Fig. 15 Fledgling: inter-relating lines indicate a passive attitude

When you begin sketching wildlife you will observe that the form of your animal subjects can be quickly pencilled in as a series of simple geometric shapes, rectangles, triangles and circles. The way in which form and proportion help express an animal's mood can also be suggested initially using this visual shorthand. Lines of tension are not usually drawn in, but with the drawing of the finch (**fig. 14**) I have shown the major lines to demonstrate that strongly opposing angles provide an aggressive expression, whereas compact and inter-relating lines, as with the fledgling (**fig. 15**), give a soft appearance. The relationships between the masses, illustrated in the drawing of the bank vole (**fig. 17**), enhance the creature's essential character.

The profile or outline of an animal will suggest that animal's attitude. An angular, taut silhouette will speak of tension and anger. Hunched shoulders and open mouths suggest threat or warning; a head turned sharply at right-angles to the body suggests fear. A soft, rounded, solid profile suggests content and calm.

Within the profile (the outline), there are surface patterns and surface textures. These behave in very specific ways as they follow the curves and contours of an animal's body, and some study will show you how. A strongly marked creature, like the serval (**fig. 16**), provides us, most obviously, with an example of how patterns alter and flatten as they follow a curved surface. A circle begins to distort as it turns away from the viewer, forming narrower and narrower elipses until, at the periphery of the curve (that point which approximates to the horizon on land), it appears as a straight line. Flat colour can be seen as a most subtle arrangement of mounds and curves simply by manipulating the superficial patterns.

The bank vole (**fig. 17**) is a triangle of simple forms when its bulk is analysed. It has no continuous patterning with which to suggest contour but its surface texture can be used in a similar way. The pattern made by fur as it curves away from the light source and ends in shadow can be readily used to indicate three dimensions.

Fig. 16 Serval: surface patterns reinforce contours and bulk

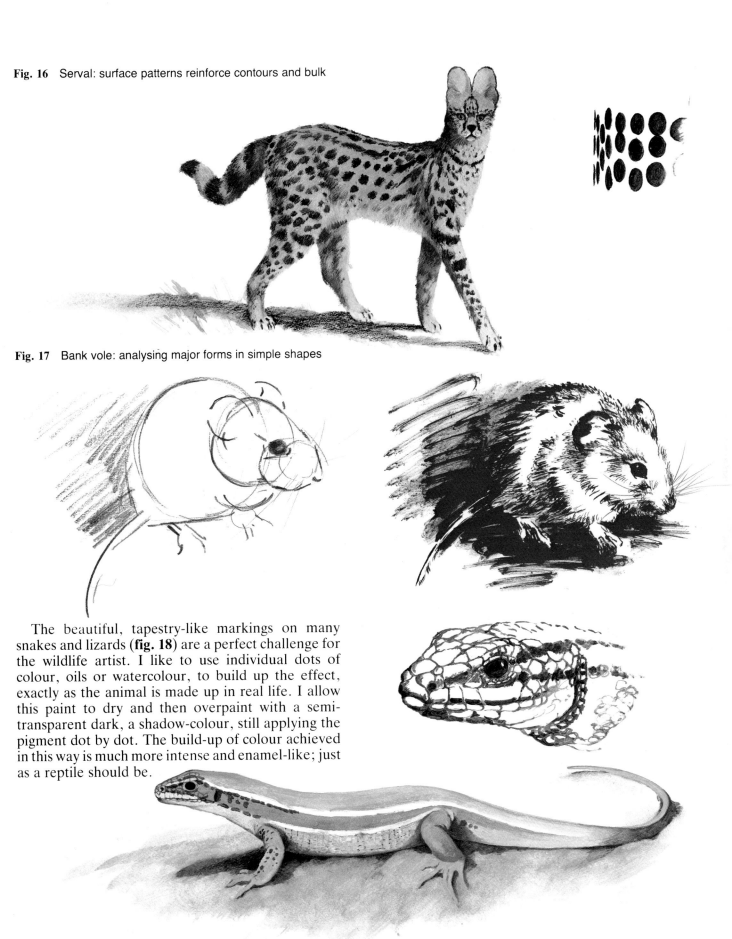

Fig. 17 Bank vole: analysing major forms in simple shapes

The beautiful, tapestry-like markings on many snakes and lizards (**fig. 18**) are a perfect challenge for the wildlife artist. I like to use individual dots of colour, oils or watercolour, to build up the effect, exactly as the animal is made up in real life. I allow this paint to dry and then overpaint with a semi-transparent dark, a shadow-colour, still applying the pigment dot by dot. The build-up of colour achieved in this way is much more intense and enamel-like; just as a reptile should be.

Fig. 18 Lizard: the use of surface patterns to enhance form and proportion

MOVEMENT

All animals have a gait which is peculiar to them alone: the stoat's snake-like scurry punctuated with sudden periscopic pauses; the loping, almost lazy bound of the hare; the quick trot of the fox. You must represent these accurately for each breed if your finished work is to be of any authority.

Looking at the drawings of the deer opposite (**figs. 19–21**), you can see the quite different forms that extended or contracted muscles make in the process of action. Once you have established the attitude of your subject, you must make sure that the musculature is modelled in the correct way for the pose. As a general rule, bent limbs carry bunched or knotted muscles which will be clearly defined by highlight and shadow; an overall rounded feeling should be aimed

for. Straight or stretched limbs look sleek and flat, and muscle shapes should be smooth and fluid, running together without much shadow contrast. The stag descending (**fig. 19**) has all the body weight on the front legs and is using muscle control to maintain an awkward position. In **fig. 20** the reverse of the above is true. Because of the extreme nature of the animal's situation, the muscles are bunched and clearly defined although the limbs are straight. This helps to strengthen the mood of the work and suggests tension in the composition. As with all detail, accuracy is essential if it is to lend any authority to the portrayal. Throughout the history of animal art, the paintings which have sought out the essential rather than the superficial have been of most lasting success.

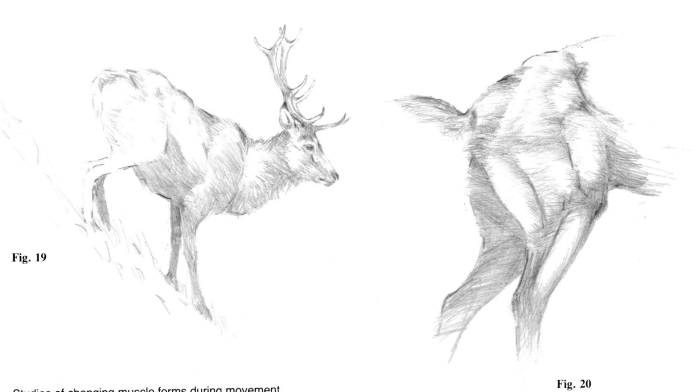

Fig. 19

Studies of changing muscle forms during movement

Fig. 20

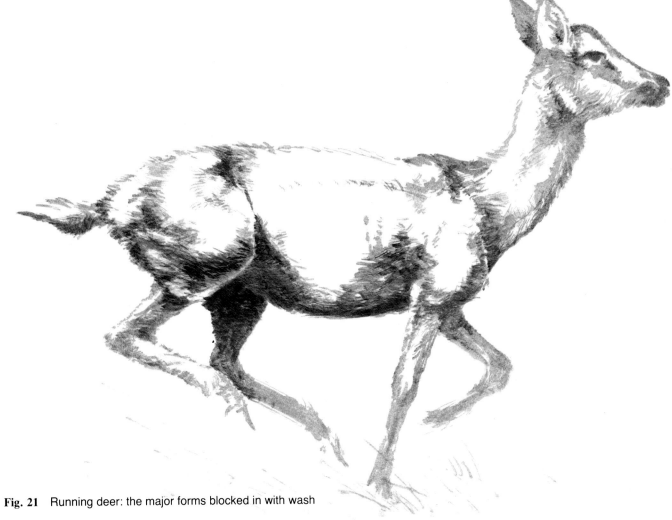

Fig. 21 Running deer: the major forms blocked in with wash

ANATOMY OF FISH

The underlying skeleton of a fish describes its proportions, its form and its action in a precise and inviolate way. The soft, flexible areas such as the belly and throat are supported by the ribs and skull without having any rigidity from bones passing through them. They are, therefore, of variable shape and size and, if twisted or folded, will show creases on the skin surface. The back (dorsal) and tail (caudal) muscles are heavily boned with fine interlocking spines originating at the vertebrae and curving out and back through these tissues. The skull is a solid shell of bone, very near the surface and allowing no flexibility whatsoever.

Once the anatomy here (**fig. 22**) is clearly understood, and the exterior detailing of a given species (in this case a common carp) is noted accurately, you should be able to draw your fish from any angle and in any shape you wish. Reduce your subject to a few essential lines and you have your proportions (**fig. 23**). Add shading and tone and you achieve form (**fig. 24**). So, if you want to show your fish leaping and twisting, know your skeleton. I think one of the nicest ways to study a fish's bone structure is as you carefully separate it from the flesh on a dinner plate; but if you can get hold of a fish, or if you can get to a museum where you can take a sketchbook, a 5 mm HB automatic pencil and a kneadable rubber and see one on display, then a careful drawing will do more for your knowledge of animal structure than twenty written works. Be very strict with yourself, however, and get your drawing *absolutely* correct, counting the bones and getting the number right, the proportions accurate, and the angles, most importantly, showing the natural line that the overlay of muscles will take when you come to paint or draw a less studied subject.

Like a beautiful engine or a great building, the exterior is arrived at only after a real awareness of the underlying structure and a knowledge of the insides are achieved. While these 'foundations' are unseen, and often unappreciated, yet their absence or an inadequate understanding of their function leaves the finished work lacking in authority and, somehow, unsatisfactory to the viewer.

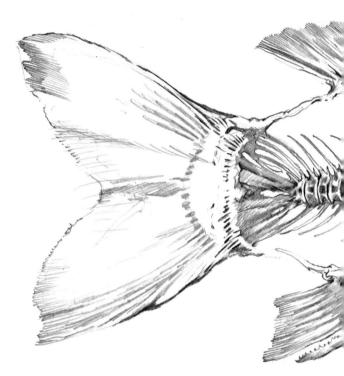

Fig. 22 Common carp: the underlying frame

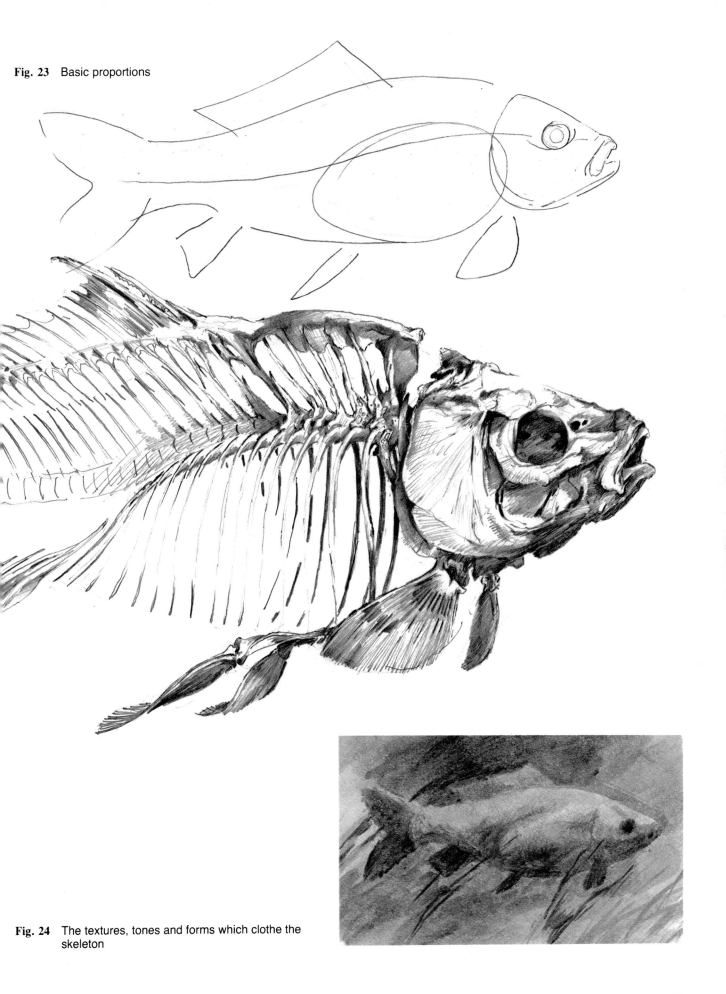

Fig. 23 Basic proportions

27

Fig. 24 The textures, tones and forms which clothe the skeleton

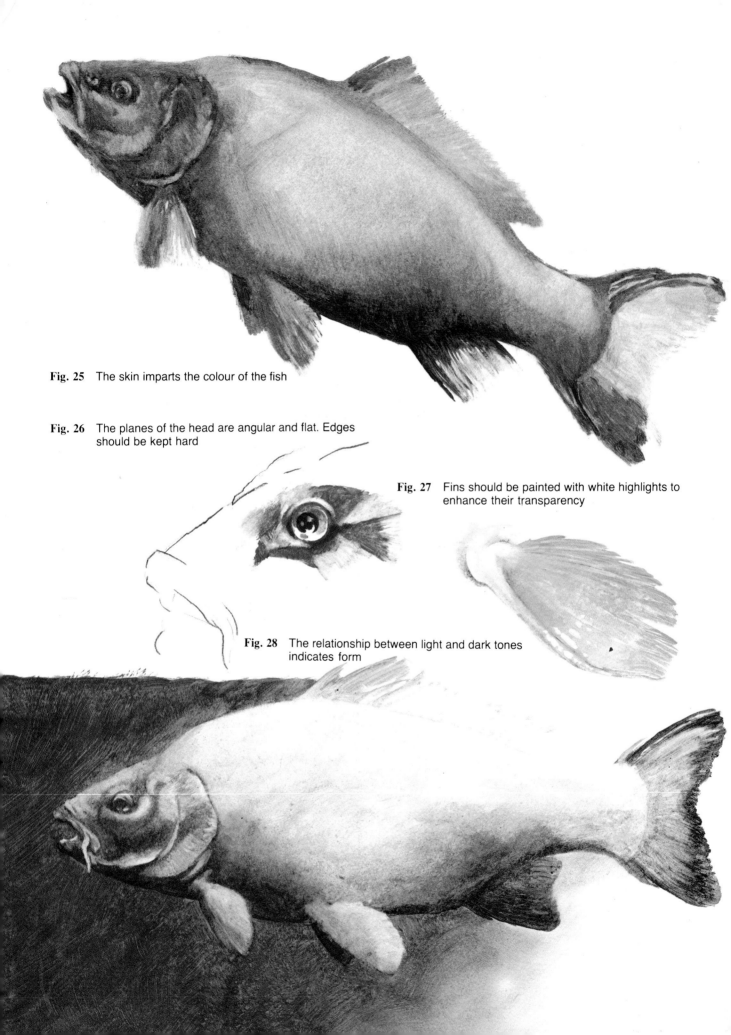

Fig. 25 The skin imparts the colour of the fish

Fig. 26 The planes of the head are angular and flat. Edges should be kept hard

Fig. 27 Fins should be painted with white highlights to enhance their transparency

Fig. 28 The relationship between light and dark tones indicates form

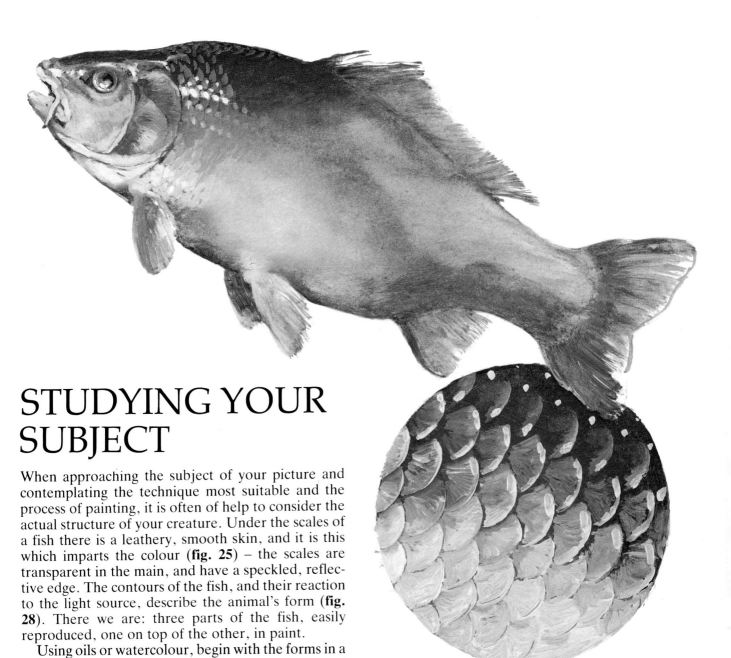

STUDYING YOUR SUBJECT

When approaching the subject of your picture and contemplating the technique most suitable and the process of painting, it is often of help to consider the actual structure of your creature. Under the scales of a fish there is a leathery, smooth skin, and it is this which imparts the colour (**fig. 25**) – the scales are transparent in the main, and have a speckled, reflective edge. The contours of the fish, and their reaction to the light source, describe the animal's form (**fig. 28**). There we are: three parts of the fish, easily reproduced, one on top of the other, in paint.

Using oils or watercolour, begin with the forms in a dark colour on white. Overlay the general colour of the fish, keeping the lighter parts of the form crisp and clean, and merging your colour into the background darks where you cover shading. Overpaint the scales, one at a time, in long, lateral rows, reflecting the general colour, and painting white (you can lay this on in a solid mass) for the underparts. This gives you surface texture and pattern, and the undulations of the rows reinforce the form, the 'roundness' of your fish. Paint any pattern the fish carries as you would build up a mosaic: use small dots of colour as 'tessare' (the individual pieces of coloured material which make up a mosaic). Your fish should now be finished, save for highlights. Any wet, slippery object will throw off pure white highlights – study the fishmonger's slab! The whole can appear a little crude, however, and it is necessary to smooth layers of overpainting into each other with a fan brush, say a Dalon Series D.55 No. 3, to achieve subtlety and realism.

Fig. 29 The technique of painting scales

Fig. 30 Fish float! A strong shadow lifts your subject away from its surroundings

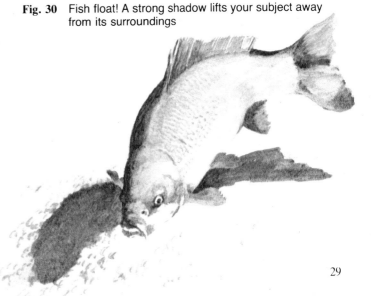

ANATOMY OF BIRDS IN FLIGHT

The curvature of a bird's wings depends on the flying (down) stroke, or the retrieving (up) stroke. A bird gains lift and forward flying speed by pushing down hard with both wings and dipping down, slightly, by using the tail. If you paint a bird coming in to land, it would look wrong seen on a down stroke, the stroke of acceleration. Similarly, if you paint a bird taking off, it would look wrong seen on an up stroke, the stroke of deceleration or braking. Think carefully of the circumstances you place your subject in and get the details right.

The striking owl (**fig. 31**) is seen in an extreme position, at the peak of physical effort and concentration. A look at the skeleton (**fig. 32**) will show you that these remarkable contortions in no way disobey the laws and conditions of the creature's anatomy, indicating just how articulated a wild animal's structure can be. Within an accurate framework underlying the finished form, there is ample opportunity to find images or compositions of remarkable impact.

Fig. 31

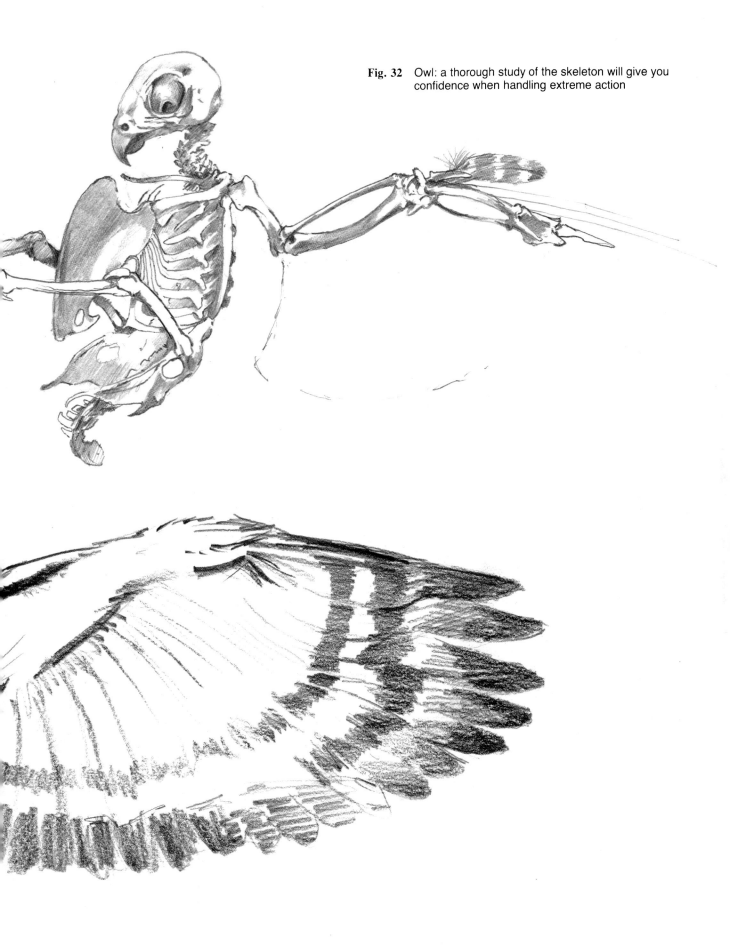

Fig. 32 Owl: a thorough study of the skeleton will give you confidence when handling extreme action

FIELD NOTES

Fig. 33 Sparrowhawk: identification sketch

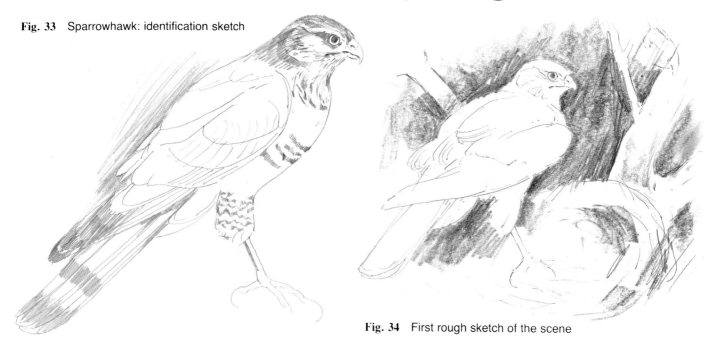

Fig. 34 First rough sketch of the scene

Much preparatory work can be done at home before you venture out into the field with pencil and sketchbook. I know of a sparrowhawk's nest locally, and decided to make use of the site for a picture. Before I went out, I drew an outline of the bird (copied roughly from a bird identification book such as *Collins Field Guide to British Birds*) in strong, simple lines (**fig. 33**). I would fill this in with more precise detail in the field. Then I sketched a rough outline of the composition I wanted and headed separate sheets of my sketchbook with the necessary components: nest, foliage, sky, branches – every detail that might enhance my composition had a page to itself.

Once in the field, and hidden beneath the sparrowhawk's nest, I positioned my equipment around me so as to keep movement to a minimum. The first drawing was a general view of the nest and surroundings and, very lucky this time, the male sparrowhawk (musket) alighting several times to feed his brooding mate (**fig. 34**). I flipped back the pages of my sketchbook to write in some plumage details on my ready-drawn dummy. As one observes a site like this for a period of time, one begins to identify the eccentric or the unusual in one's field of view. Here, the hawks had included the red and white cardboard of a cigarette packet in the structure of the nest, and it struck an incongruous note – a device which might well work in a picture to highlight the subject. All these details should be drawn and described.

Always remember to keep a weather eye on good background material for your paintings: bark, rock, earth banks with roots, plants, branches, posts, gates,

water margins, nests – the list is endless. Keep notes on colour and collect samples of leaves, twigs, and the like, from your background scene, to give you a base colour guide. Also record the creatures you might expect to see in any environment you consider worth noting, and look around for actual signs of the wildlife which has frequented your site. The more knowledge you acquire, the better your work will be. When you feel happy with the amount of field work done, return to your studio and start cross-referencing with photographs of your subject from books and natural-history magazines, and build up a set of detail drawings which describe any aspect of your picture which demands absolute accuracy (**fig. 35**).

By now you should have a very clear picture in your mind of what your finished piece will look like. Make a drawing, to size, of your composition and include, in as much detail as possible, all the elements you have gathered from your field trips and your research (**fig. 36**). It is now that you will uncover any weakness in your composition and can begin 'honing' or 'fining' your picture: rounding out the work with supporting detail; altering the attitude of your subject a little here, a little there; sharpening the look of the thing so as to get the maximum effect from your images.

A sequence from field to finished drawing in the studio allows you time and practice to get to the heart of your subject. As you work on you will familiarize yourself with all aspects of your picture, and by the time you come to put paint on paper or canvas you should know, in every particular, the drawing, the composition, the sequence of painting and the degree of finish that you require to achieve your goal.

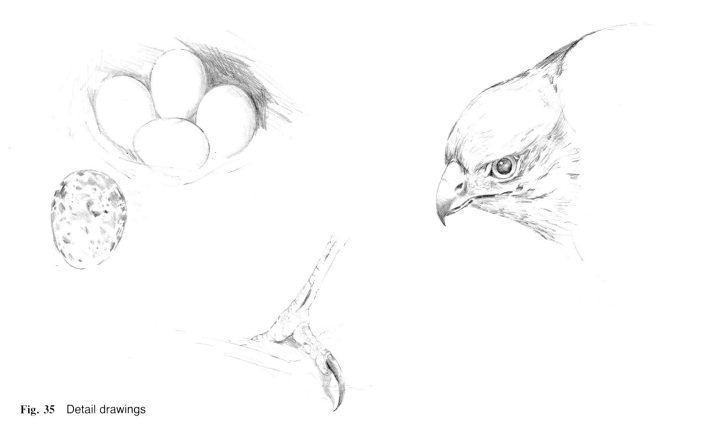

Fig. 35　Detail drawings

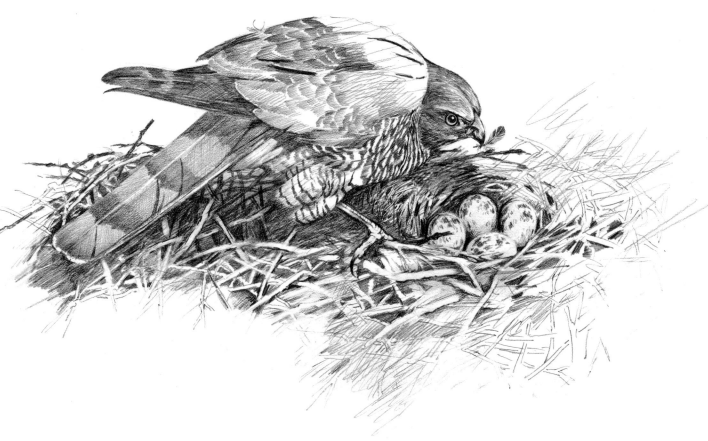

Fig. 36　Finished studio rough

STUDY OF FEATHERS

This classic study (in oils) for your reference library, detailing a bird's wing, will give you much more information than simply shape and colour. The relationships between colours can be projected on to the canvas as a guide to colour over the whole of your painting, and the proportions of bright detail to drab background can be ascertained and used as a guide for your work in general. The careful study of these details of nature in this way can give you valuable guidelines which you will be able to apply to all aspects of your art.

Pin up your model close to the work surface and sit down comfortably to study it. Look and concentrate for a while, getting a general feel of the overall colours, and then decide how you can achieve an accurate result with the *least* number of tube colours possible, squeezing a small amount of each (about the size of a pea) on to the sides of your palette (**fig. 37**). Use a pencil brush (Dalon D.77 No. 3 or 4 is about right) and mix a light background colour to base your work. (If you feel unhappy about drawing

straight on to the paper with a brush, draw a faint outline with an HB fine point first.) Keep your paint thin and transparent and mix only with diluent (turps substitute or white spirit) – *no oil!* Let the brush make its own feather effect by pushing the paint around with flicks and short strokes, and let the brush hairs spread and separate. The colour should be no more than tinted spirit, very transparent (**fig. 37**). Work back from the wing tips with a dark colour (**fig. 38 and 39**), then overlay with a solid white to give the barred effect (**fig. 40**); let the colours blend at the edges on the paper. Fill in the dark patterns on the small underwing feathers and then paint up to them with white. Allow an hour for drying, then, using a very transparent brown with a *hint* of blue, brush in the shading with a small fan (**fig. 40**). If you notice colour coming off and mixing with your shadow colour, stop and leave to dry more. Finish with a small pencil brush (Dalon D.77 No. 1) by outlining and sharpening up details and edges where necessary. Wait two days, then fix with a matt spray.

Fig. 37

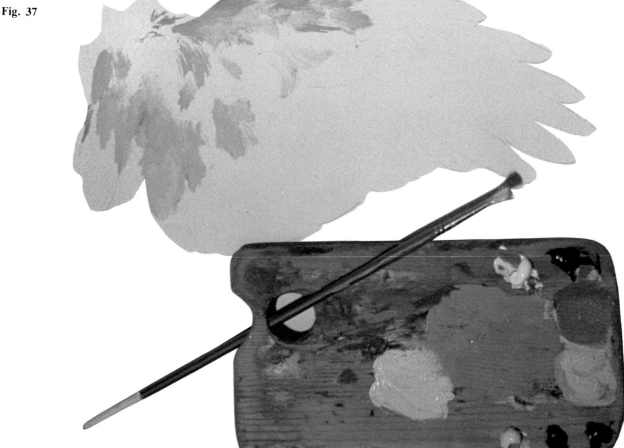

Fig. 38 First stage

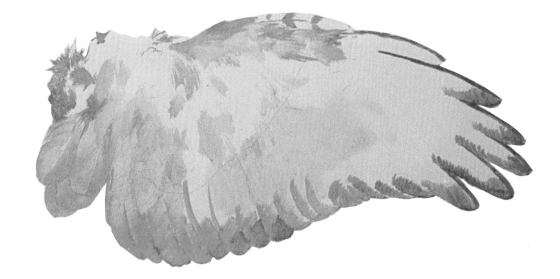

Fig. 39 Second stage

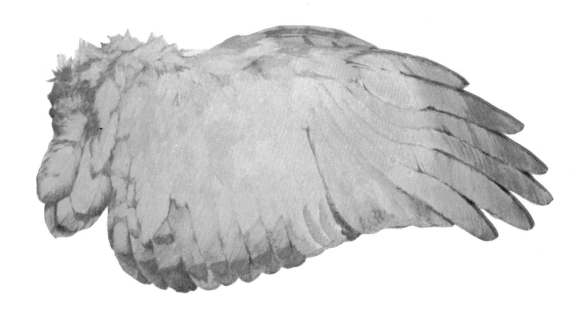

Fig. 40 Finished stage

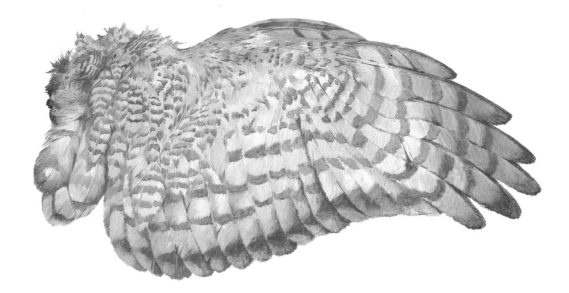

PAINTING BUTTERFLIES

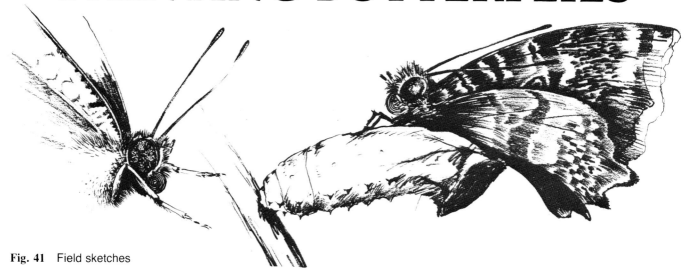

Fig. 41 Field sketches

There are certain subjects which require a special approach and are very demanding of an artist's technique. Moths and butterflies are the most subtle and delicately marked of all insects, and their caterpillars are similarly patterned and shaded. Careful observation and plenty of drawings in your field notebook must come before you can approach butterfly painting (**fig. 41**). Study the way the wings appear from different angles and try to avoid the obvious symmetrical pose with both wings laid flat. Detail is essential with insects: make as many different drawings of detail as you can and make them quite large, say four times larger than life. The intricate structures should be carefully drawn with an HB pencil on white cartridge.

Their size presents a problem to begin with and, generally, I like to compose a picture including moths or butterflies by having a wide, drab backdrop with the insects as exquisite droplets of brilliant colour placed carefully within the picture plane but quite small and precise. The background needs research as most butterflies are specific to certain plants. It is a good idea to make notes on foliage and any other features in your subject's immediate surroundings.

Once you know your butterfly and the relevant foliage, paint in with a solid, dark tone, a background colour which complements your subject. The brightly coloured Vanessids (Red Admiral, Emperor, etc.) can take a strong range of good greens (**fig. 45**), but the Fritillaries or Meadow Browns would be overpowered by these and need a much more neutral tone; green-brown or amber-brown would enhance and heighten the impact of these tiny brown/red butterflies, and an underlying shadow will throw the subject into relief.

The patterns on the wings are made up of minute scales, each a distinct colour, and, if you can, you should reproduce these patterns similarly with paint (**fig. 42**). Painting two butterflies together gives you the opportunity to show the underwing as well as the dorsal colour, but always work from actual specimens when attempting this particular scene.

Caterpillars (**fig. 43**) must be accurately drawn and coloured, too, and should be identifiable as to type. Use an HB pencil to get detail and watercolour to make a side-view reference picture for your library. Look up the animal's proper name and label your painting with it.

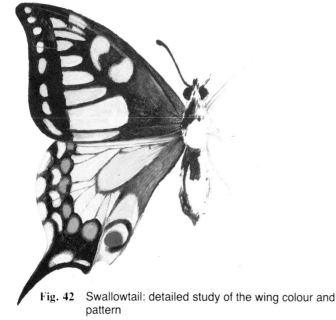

Fig. 42 Swallowtail: detailed study of the wing colour and pattern

Fig. 43

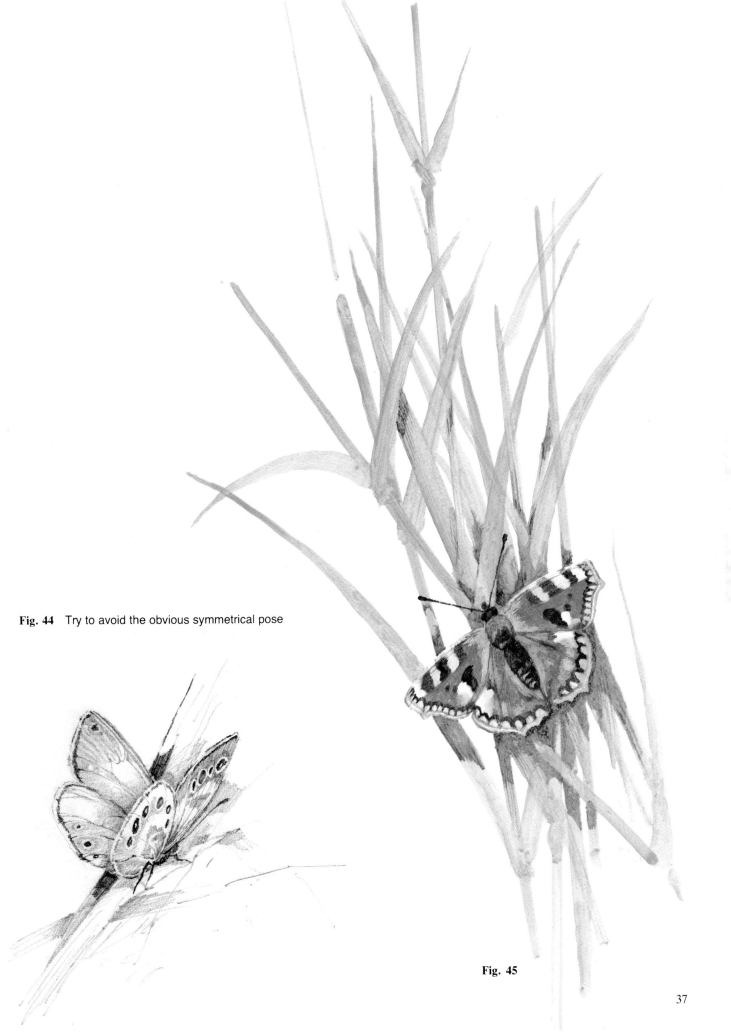

Fig. 44 Try to avoid the obvious symmetrical pose

Fig. 45

COMPOSITION AND INTERPRETATION

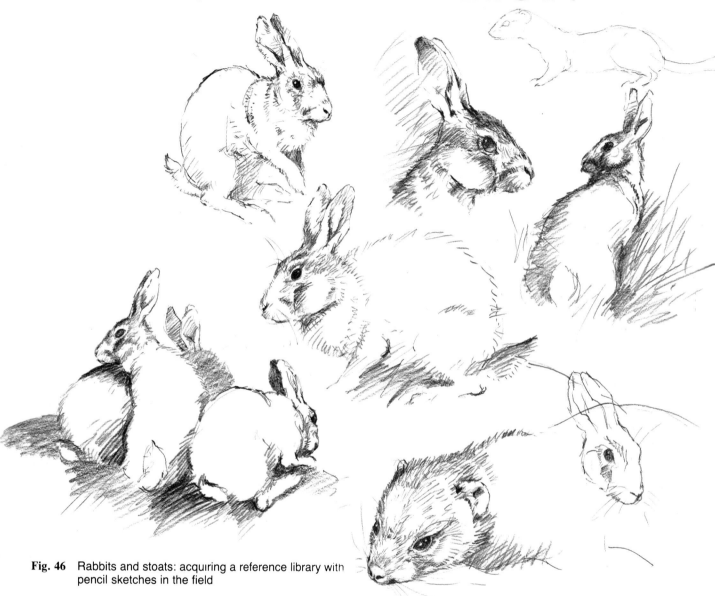

Fig. 46 Rabbits and stoats: acquiring a reference library with pencil sketches in the field

I can give no better advice as you consider what to paint than to choose a subject you know. Painting a wildlife picture is, in part, a question of using your artistic skills to reveal something of nature which the viewer would otherwise not be privy to, and it is the responsibility of the artist not to misrepresent his subjects but to enhance and add to the viewer's awareness of them. It is difficult enough coping with the practical problems of technique without adding to the task. A subject you are familiar with will also give you confidence in drawing, painting and scale.

Suppose the scenario for your canvas is a stoat and a rabbit: an elusive scene that few can have witnessed at first hand. Which animal do you feature most prominently? The rabbit, unsuspecting, browsing in the foreground, or the sinister stoat, an ominous shadow in the rear? Or do you paint the stoat almost filling the frame? Do you intertwine the two forms almost as a heraldic device, implying the more profound relationship of the two creatures in the wild? These are the kind of questions every artist must ask himself when planning a composition of this kind.

In this instance, I felt that the character of each animal should be delineated. The stoat I wished to appear lithe and ruthless, the arch predator, crouched and determined (perhaps with a glitter of white as the fangs appear behind the smile). The rabbit was more difficult; no longer warm and fecund, chewing

dandelion or sorrel, enjoying the summer heat, but the quarry, hunted and caught, with an awareness of its part having been played and resignation in its eye. There was a vacancy of expression in the rabbit which I wanted to paint to complement and contrast with the glittering ferocity which the lip-licking stoat imparted (**fig. 47**).

Begin with sketchbook and pencil and start playing with shapes taken from your field notes, establishing scale between the principals (rabbits are bigger than stoats, but by how much?) and rhythm (**fig. 46**). If you cannot find a stoat in the field you may have to resort to photographs. Think of the light and dark of the backdrop as you position your subjects within the picture plane; think also of the most advantageous point of view – choose one that most helps the impact of your scene. Can your viewpoint be enhanced by a close-up? Do you want to contrast the lovely landscape with the teeth and claws? Think of yourself as an architect drawing up a groundplan before attempting to build the reality. I like to consider the subject of a picture as I might chance across it in the wild: a fleeting glimpse of an animal poised before flight. Such an image should be fixed as soon as possible in the sketch form with notes. Your painting should attempt to subdue the less important parts of the picture whilst spotlighting the most relevant details. I sometimes use a bright shaft of light in an otherwise shaded scene to leave absolutely no doubt as to the painting's focal point. This use of shadow and illumination is a very useful tool in the wildlife artist's range of techniques, considering the elusive nature of his subjects. Bearing in mind the overall tone of the piece, begin sketching in these darks and lights in your composition (**fig. 48**).

The background components can be reduced to textures and forms of an almost abstract nature at this point. Positive lines, such as branches or reeds, and negatives such as shadows or spaces, join together to form pointers or indicate direction. They are valuable devices for leading the view to the chosen centre of the composition, in this case the glitter in the stoat's eye. Establish bold lines. Do not be half-hearted about relationships. Do not allow forms to touch just at the edges as this is awkward, but keep them well apart or make them overlap strongly. Make two cut-out shapes representing the stoat and the rabbit and move them about until you discover the most read-able and exciting position with curves and lines flow-ing. Move a leg here or a head there, if it helps; do not be limited to your original pose if it conflicts with its counterpart, however pleased you are with that shape in isolation. Rhythms should be achieved in tones of light and shade. The attitude of a creature when frozen in two dimensions must suggest the pace and vitality of the living animal; the stoat is lithe and fluid, the rabbit stolid and shy. There is always a place for deliberately rendering a subject out of character for the sake of tension, but be careful – like garlic in a good meal, use sparingly.

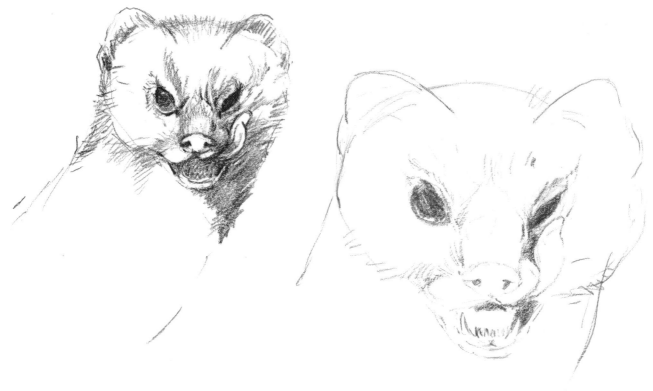

Fig. 47

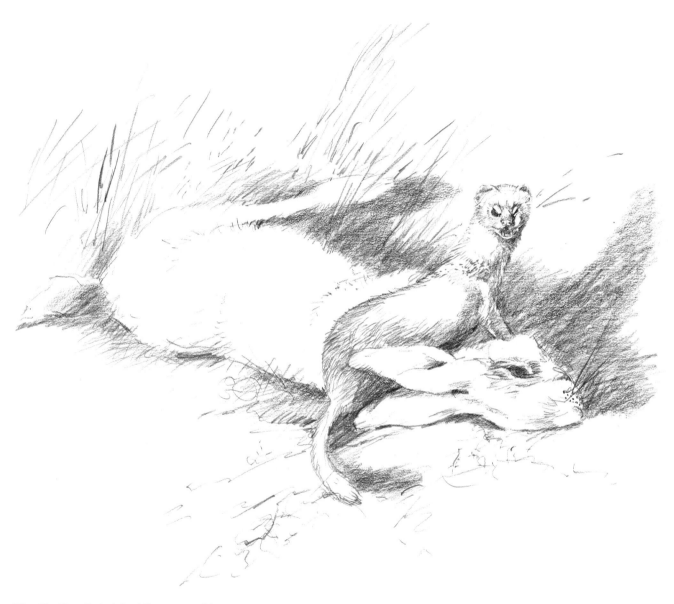

Fig. 48 Pencil sketch of the composition

You are now ready to start painting. Clear a space for your reference material – photographs, specimens or whatever – and make sure your equipment is prepared. Having established the composition after experimenting with pencil and sketchbook, and deciding to work in oils, the major lines and shapes must be transferred to the canvas. I use one of two methods: I cover the back of my rough drawing with pencil shading (a Black Beauty is useful here), position the sketch on the canvas, and go over all the main lines and forms with an HB pencil. This draws through on to the painting surface rather like a carbon

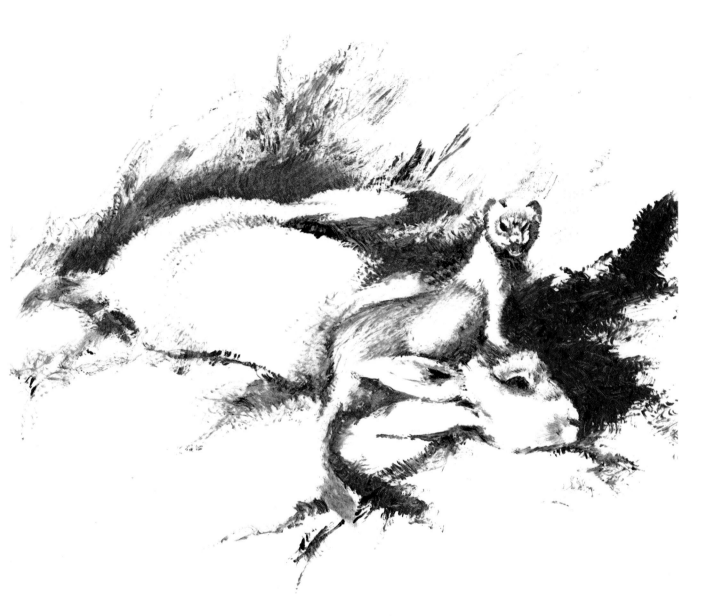

Fig. 49 Establishing the light and dark tones

copy. The other method, for work that needs to be scaled up in size, is to draw a grid of squares over the rough sketch, then an equal number of squares of sufficient size to cover the canvas. Each small square on the sketch can be accurately redrawn in its corresponding large square on the painting surface. Once the rough is transferred, I like to fill out the layout with charcoal, concentrating on the main areas of light and shade. This would be wrong for watercolour as the charcoal would dirty the subtle washes, but oil assimilates charcoal quite readily.

The overall colour of **fig. 49** is a green-brown, so I mixed a dark tone with Vandyke Brown and Prussian Blue and started painting in the shaded areas with a Dalon D.22 $\frac{1}{2}$ inch flat. When this was complete, I stood back to see, for the first time, the composition as a whole. It was at this point that I started changing a line here or a shape there, beginning to fine the work as I went along. Never be strict about following original lines; it is not until the brush begins to bring out the images on the canvas that weaknesses can be remedied or additions made for improvement. Be flexible and prepared to change and adapt as your work progresses.

I worked into the picture while the shadow colour was still retrievable to blend colour and texture into shadow. (Although apparently dry, the paint was still soft enough to be made fluid again when brushed with turpentine. The more linseed oil in the original colour mix, the longer it will stay 'retrievable'.) The painting was now at the stage shown outside the central square, with detail beginning to emerge and colour being enhanced (**fig. 50**). In some parts of the background this soft focus and vague detail was as far as I would go, preferring to save the high finish and strong detail for the important central area of the picture.

The stoat and the rabbit's head, and the way that these two intertwine, make a clear statement about the creatures and their relationship in the wild. The pose is the traditional one for victor and vanquished and this area of the painting contains the essence of the work, so I concentrated the strongest painting here. I brushed in the shaded fur with a Dalon D.66 No. 1, teasing out the earlier shadow colour and blending the two. Into the wet paint of the shadow fur I painted the lighter shades until I was painting almost white fur in strong illumination. These areas were blended into one another so as to give an even transposition from dark to light.

The face of the stoat is the very centre of the piece and was painted with most strength. I painted in the overall rust colour first, then into this colour placed the eye and the inside of the mouth with Lamp Black, straight from the tube. The white fur was painted on so as to use the dark underpainting as shading and modelling for the features; by painting white on with a single stroke it remained clean white, but by using more than one stroke and pushing the paint about, the undercolour started coming to the surface and 'shaded' the white. The resulting tones give a remarkably accurate rendering of fur and perfectly describe the creature's facial expression. The fine hairs on the muzzle and brows were made by scratching with a compass point; a finer and sharper effect than a paintbrush could achieve. The highlights in the eye are Titanium White straight from the tube, dotted in with the point of a Dalon D.77 No. 000.

At this stage I looked at the work as a finished piece; as a whole. I reinforced the shading around the subjects so as to bring them well forward, and worked on odd details of grass, background and subject until I was satisfied that I needed to go no further. The work was put away flat and left to dry thoroughly. After a week or two, I signed the picture and varnished it.

Fig. 50 Developing colour, texture and detail

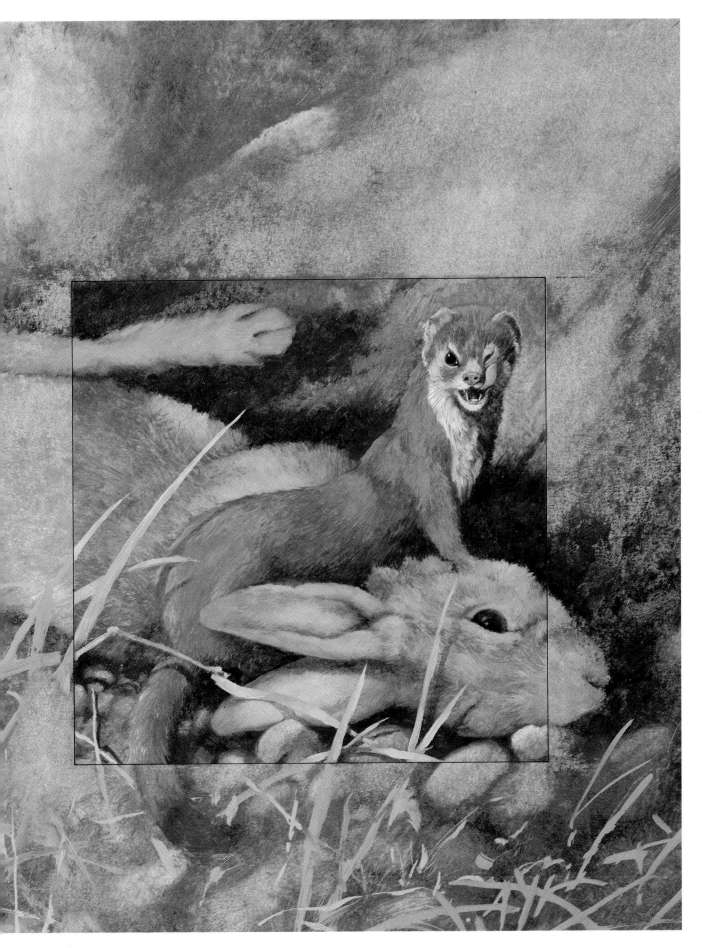

DRAWING IN THE FIELD

Certain circumstances will not allow you merely to sketch in pencil or charcoal and then return to your studio to work up your painting to a finish. Sometimes you will need more studied observation on site. The trout stream is a classic example. Fish appear fleetingly, if at all, and can only really be drawn from memory. When dealing with a subject like this, stand and watch for as long as you can – patience here can be worth more than its own reward. Build up a mental picture of your fish, as you watch them, and look for regular or recurring patterns of action. A rising trout comes straight to the surface then curves into a U shape to dart back to the bottom. Fish holding their position in a current, wriggle constantly in a shallow S shape, while fish holding their position in still water, stay very straight, using only the movement of their fins. While these images and observations are fresh in your mind, try putting them down on paper (**fig. 51**). Pencil in essential lines quickly and in one stroke (the line from the fish's nose, down the centre of the back to the tail, is the only one you need worry about here), attempting the fluid movement of the creature itself. Draw in possible positions of fins. If your sketches are unsatisfactory to start with, stop drawing and start

looking again. Eventually you will have a few pages of fish in all manner of poses. Even if you do not have the fish there that you need for your painting, by now you will know so well how these creatures move that you will be able to draw it from memory.

The water, water-weeds and banks are permanent fixtures, yet a pencil sketch can rarely carry enough information about such a scene, so an oil sketch, done on the spot, is needed. For this, use a flat, smooth-surfaced card (Bristol board is good) cut to a convenient size to carry (A4). Card absorbs oil and spirit quite quickly and your sketch will dry nicely before packing to carry home. The use of a brush handle or a bamboo scraping tool is much more effective on a smooth surface and much of your sketching will be of this type; brushing on solid areas of colour and then scraping back to the natural white surface beneath. Be quick and bold as you work. It is the impression you wish to capture, not the detail. Look and look again as you work.

Make sure you establish the main areas of light and dark, and begin to distinguish between below and above the water surface. Try to capture the distortions that an irregular water surface imparts to solid

Fig. 51 Trout: the field sketch in charcoal pencil

Fig. 52 First stage

Fig. 53 Second stage

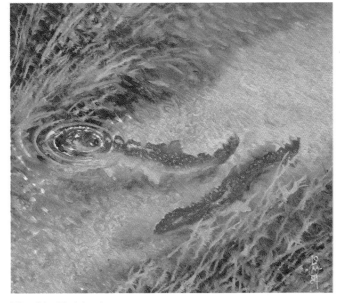

Fig. 54 Finished stage

objects seen beneath it. To do this successfully, make your brush behave like the water itself. Apply a dark colour, representing the overall tone and hue of the water, and with a scribe or scoring tool scrape the forms of the weeds into the wet paint (the dark colour may need lubricating with a little linseed oil, once or twice, to keep it from drying out), building up a general impression of the masses and forms made by the water-flow on the weedbed (**fig. 52**). Using a dry fan brush, Dalon D.55 No. 2, draw a series of zig-zag strokes across the line of the weeds, which will reproduce the effect of ripples by distorting the lines of the weeds. With a small pencil brush, Dalon D.77 No. 1, loaded with a pale green, wriggle in the colour of the weeds, following the distorted lines of the fan-brushed base colour. Follow this procedure over the whole of the picture area, continually stopping to blur edges and distress and distort hard lines with your No. 2 fan (**fig. 53**). In my sketch I made the rising trout the focal point and I wanted the radiating rings of water from this rise to enhance the fish like a halo. I scraped the series of elipses (circles seen in perspective) with my brush handle and softened them with the No. 2 fan.

Now for the fish themselves (**fig. 54**). There is a problem with painting fish. The light shines on them from above, where they are dark coloured, and they are in shadow on the underside, where they are light coloured. So, we must paint the white in shadow and the dark illuminated. Observation of fish in water is the only answer to this problem, and you will soon see that, in certain lights and at certain angles, the fish can be lighter above than below. In my sketch, however, with a point of view from fairly high above, the relationship of light and shade to colour is dark above and lighter below, as one would expect. Paint in your light colour, then the dark, merge the two colours with a Dalon D.88 $\frac{1}{4}$ inch, then dot in the pattern on the flanks of the fish. Blur and soften by flicking your No. 2 fan over the whole surface, and repoint (make sharp and clear again) any areas that you feel need precision and clarity, such as the heads of the fish. Dot in highlights with Titanium White lifted straight from the tube and soften these by fanning the wet paint diagonally left top to right bottom, then left bottom to right top. Keep a light touch and a free-moving hand working from the wrist.

This sketch took me less than ten minutes at the riverbank and all the materials were carried in a small box easily contained in a satchel. The paper was Bristol board mounted on offcuts of corrugated card (cut from the clean, flat sides of cardboard boxes) with an aerosol adhesive. The end result, in conjunction with photographs of weed and water detail, and text-book references for the fish, contained everything that I needed before starting on a finished work back in the studio.

THE DEGREE OF FINISH

Many people see wildlife painting only as very highly finished and photographically realistic. However, sketchy impressions can often convey much more precisely the nature or form of your subject and, after all, wild creatures are usually seen only as a series of fleeting images conveying an 'impression' of form rather than a clear description. Any artist will tell you that one of the most useful skills you can develop is the ability to recognize when your piece of work is finished – knowing when to stop. When I say finished, I must underline that I do not necessarily use the word in the sense of everything being complete; a few quick lines describing a running fox can be 'finished' as a picture. When a painting says everything you wish it to say about your subject, any further painting is merely embroidery and will only distract the viewer.

The picture of an otter was started with a conté pencil drawing (**fig. 55**) taken to a fairly high degree of detail. Colour washes in oils or watercolour were then applied, beginning the process of building up colour in layers. Darker colours, as for the deep water behind the lily pads, were strengthened with heavier washes until the desired degree of opacity (the 'solidness' of a colour) was achieved (**fig. 56**). The form of the animal was flashed in with ragged strokes, using a dark shading colour and a medium round-ended brush, and these were blended into the background with a fan brush to give the indistinct, underwater feel. The lily pads were given detail – ribs and shading – with a No. 2 or 3 round-ended brush. Highlights were sketched in (**fig. 57**), and as I was dealing with moving water, the brush (in this case a fairly large pencil brush) had to be kept loose and fluid. The difference between fur under water and above it had to be made clear (this defines the plane of the water surface as well) and colour was the simplest method of achieving this. The final section (**fig. 58**) shows high finish. The diffused highlights in the foreground were painted by 'pointing' – thick dots of pure white were put on the canvas and then 'flared' with a small fan brush whisked gently back and forth across the points of white along both diagonals. The fur about the otter's face was painted with a fine pencil brush (No. 0), applying the colour in strokes along the lie of the pelt and shading to bring out the forms of the face. The eyes were clearly delineated and the highlights put in, using pure white. The painting was complete.

However, whether the last stage (**fig. 58**) – or come to that, **fig. 56.** or **fig. 57** – although highly finished, says any more about otters than the original conté drawing (**fig. 55**) is debatable. I suspect not.

Fig. 55 First stage

46

Fig. 56 Second stage **Fig. 57** Third stage **Fig. 58** Finished stage

SHORELINE SNIPE

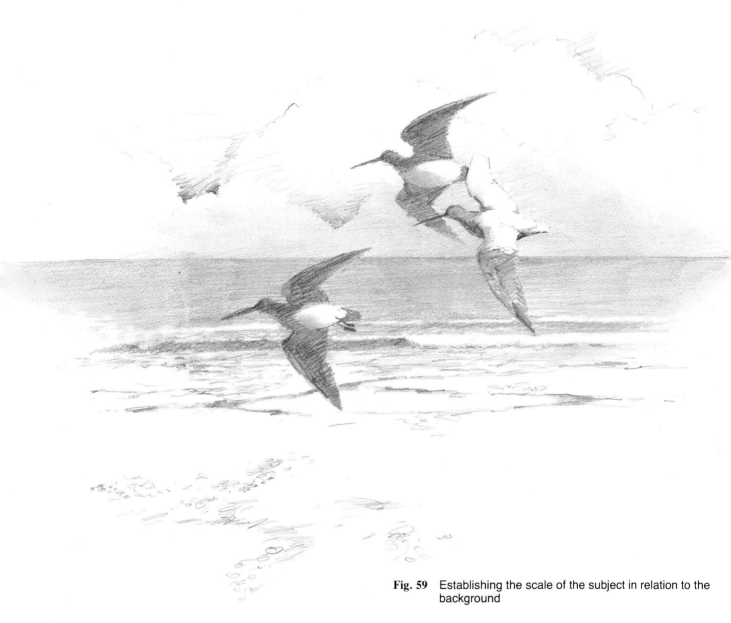

Fig. 59 Establishing the scale of the subject in relation to the background

Now you have had some practice at drawing specimens at your table, you will be able to collect field notes in preparation for a finished work. Let us go step by step through the process of translating a scene into an oil painting.

The scene will probably have suggested itself as the basis of a picture if you are familiar with it (stick to what you know!) either because of a sudden change of light or, as in the case of the seashore scene here, the arrival into a known landscape of some unusual visitors. The flock of snipe stayed for several days and I studied them with binoculars for a day before going out with a pad and a 5 mm HB propelling pencil (always with a sharp point) to get some sketches.

Shapes and patterns as the birds fly in groups; details and notes – length of wing, bill, body, etc.; size and position relative to the horizon and tideline; atmosphere and lighting; notes on colour: all this information was needed (**figs. 59 and 60**). As you study to collect such information you are absorbing the overall feeling of the place. Written notes are just as useful as drawings, and if you have a watercolour box, paint a spectrum that sums up the colour of the scene. In my painting (**fig. 61**), amber, grey-green and brown, with peripheral splashes of blue and reflected white light, were all I needed. Do not try to use every colour in your box in every picture you paint. Less can very often be more.

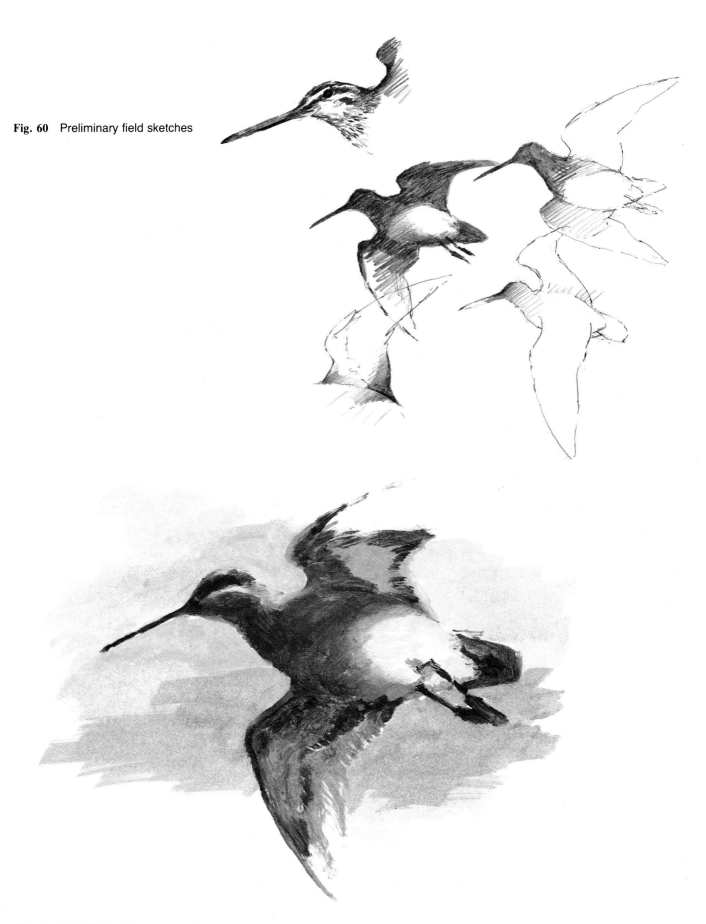

Fig. 60 Preliminary field sketches

Fig. 61 Establishing the colour scheme

Back in the studio, after toying with a sketchbook of white cartridge and a 6B pencil and trying out different views, I had a fairly clear idea that my picture would be a clear, brightly lit, but slightly wintry seascape, with my snipe, like a litter of windblown autumn leaves, cascading across it as they coast down to land. I wanted to capture the overall pattern of their flight, rather than detail, so I could light them strongly – some almost silhouettes – as if by a high sun. This was also very dramatic and provided a strong, dark pattern against a soft, pale ground. The birds cut very positively across the strong horizontals made by the sea. A soft reflective feel to the sand made the whole background very watery, also in contrast to the snipe.

I quickly sketched in the birds, and when the flock was right – the right number and weight – I tried on a piece of tracing paper various possibilities for the horizon and tideline. When satisfied, I marked them in on the watercolour and began painting (**fig. 62**). I painted in the sea, the sand and the sky with thin washes, building up to the intensity I wanted, using a generous sable ($\frac{1}{2}$ inch). As the pencil lines would show through I could paint right across the picture – I did not try to paint round the birds. Then, with a No. 1 pencil brush I sketched in the shadows in brown, and when correct in strength, I used just a wet brush to tease the brown out over the remaining areas of the birds. I was now familiar with my composition to the point where my finished oil painting could be executed with an absolutely clear idea as to the order of work, the colours involved and any alterations or corrections that might be required. I had also eliminated the awful business of staring at a completely blank canvas with a brain to match. An image needs time to settle, especially for the person responsible for creating it, so I gave myself some time to study the picture before I started on my canvas. I put it out of sight for a while then came back to it fresh. I sometimes look at my work reflected in a mirror – you will be surprised how fresh your view of a piece of work can be by using this trick.

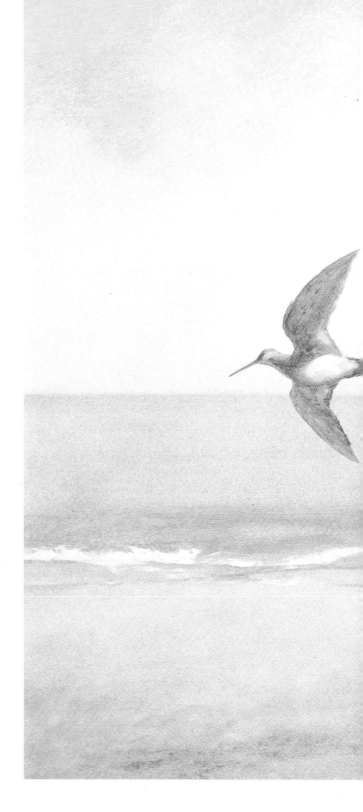

Fig. 62 Watercolour studio sketch

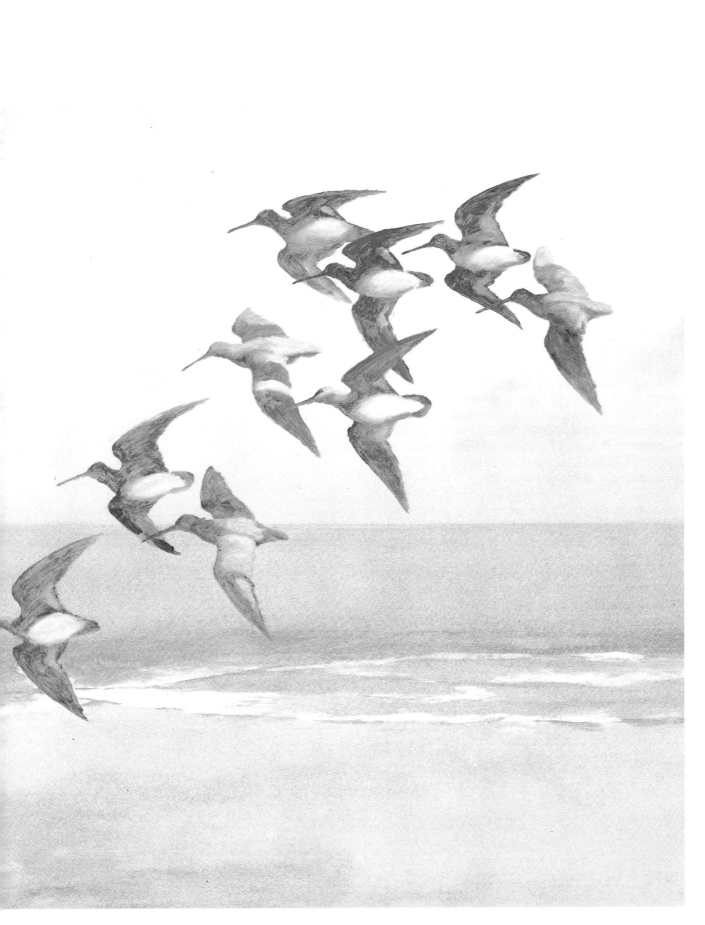

I like to transfer a very precise composition like *Shoreline Snipe* in a very precise way. Tracing the major lines and marks off the watercolour, I began to redraw them on to canvas primed with gesso (a creamy plaster giving a smooth, paperlike surface), using a 2H pencil and carbon paper. The sky was painted in one 'pass', using the watercolour pinned to the board to the left of the canvas for reference. I mixed colour as near to the watercolour as possible then put it on the canvas with a Dalon ½ inch flat. Texture and inconsistent paint density came automatically as the brush worked across the gesso. I blended out those textures which I did not want with a Dalon No. 6 fan but some enhanced my painting beautifully and these I kept in – always look out for the 'happy accident'! I used a maul-stick 1 metre (1 yd) long to help me rule in the horizon across the canvas with a Dalon No. 3 flat, and then painted the sea from this point down. Remember that distance softens colour; I painted with increasing intensity as I came towards the tideline. I left the waves until the sand was painted in. By using colours from the sky, I could achieve a reflective surface on the sand (always softening and blending with a fan) and the desired wetness. The waves were painted with pure white, one side being left hard, the other blended out. A touch of shadow between the leading edge of the waves and the wet sand seated the water firmly on top of the land, where it belonged.

By this time, only the birds remained. An exact copy of my practice with the watercolour sketch, building up to just the right strength and opacity, achieved the correct result, and by being careful to paint all overlapping forms in the correct order, I completed the painting (**fig. 63**). If any areas of a finished picture seem harsh or raw, wait until the paint is just going off and then dust all over with a large fan, making doubly sure that it is dust-free and clean. Then, only a signature is lacking.

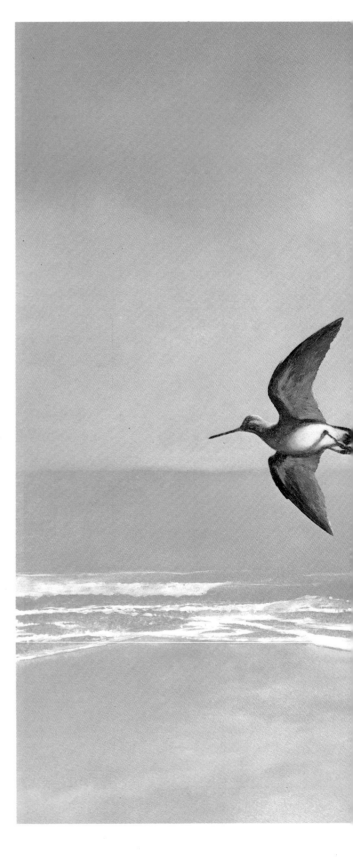

Fig. 63 *Shoreline Snipe*: finished oil

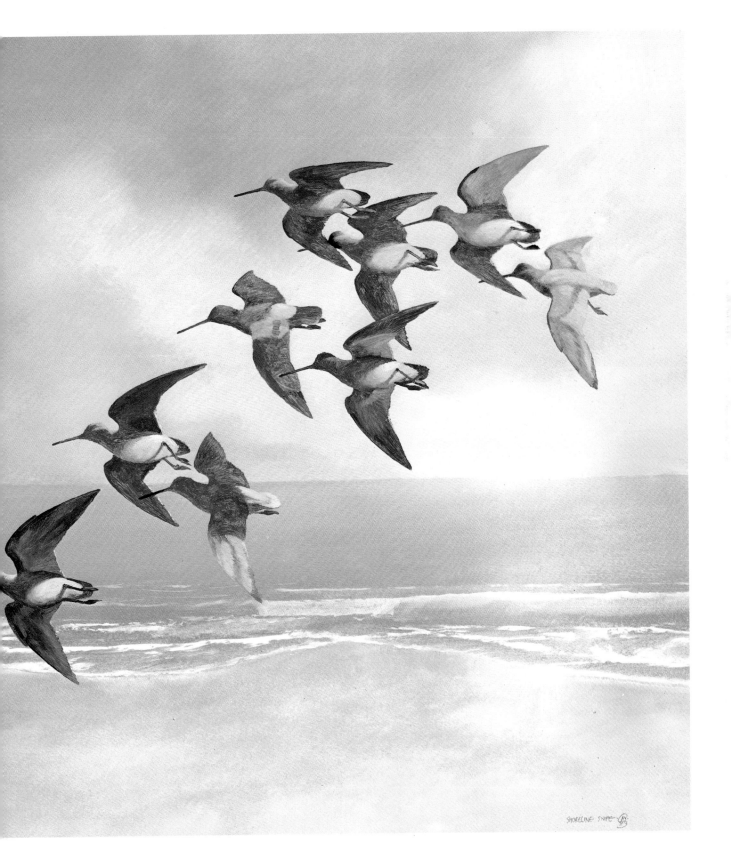

SHORELINE SNIPE

GALLERY:
OBSERVATIONS AND DETAILS

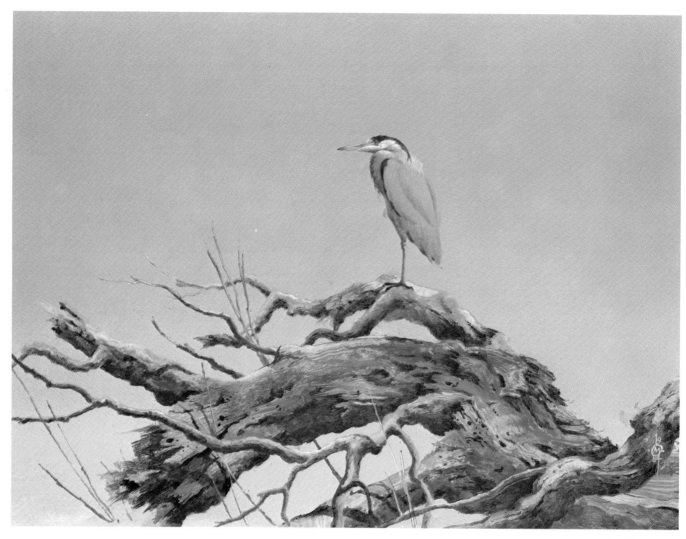

Fig. 64 *Heron*

The pictures here are all works which were commissioned or painted to a commercial brief, for publishers or industry. They have a superficial similarity, being the work of one artist, yet each one makes a special point and represents the solution to a different problem.

I have described each picture bearing in mind its one special facet, whether that be the technique of painting, unusual composition, or unexpected point of view. A painting can, and perhaps should, contain all of these points, yet these pictures have been selected because each one is an example of how one particular problem was solved. They were all achieved using the methods and techniques described in the preceding chapters, and where details are illustrated they are shown at actual size.

The heron (**fig. 64**) is a creature hardly ever seen at close quarters. This leaves the artist with two possibilities: to represent the bird in a natural way and paint it as it would naturally be seen; or to give the viewer the benefit of the artist's ability to get behind the scenes or into otherwise closed places. I felt that this bird was distinctive enough not to get lost in the wider view, and I consequently saw it as part of a much larger landscape. The three main elements – bird, tree and background – are each quite distinct in texture and act as foils, one against the others. Another important consideration to be taken into account is the size of the bird: big enough to carry some degree of detail (especially about the head), yet small enough within the picture plan to seem hidden and secret.

The bee-eater (**fig. 65**) is not only exotic in colour and form, but in life-style. No background was necessary in this painting except for a suitable overall drab to offset the jewel-like quality of the bird, so I painted an earth bank, grey in general colour and featureless save for a strong diagonal to 'raise' the bird off the canvas. The hole in the bank, obvious home of the bees, gives a reason for the action taking place. The bird was painted in flat colours as this is how the creature would be seen flitting by. One wing was left unpainted: the 'happy accident' which lent some life to an otherwise stiff watercolour composition.

The detail of the bee (**fig. 66**) shows another example of the 'happy accident'. I tried painting the flashing wings of the flying insect several times and found it most difficult to resolve properly. I decided to erase what I had painted with a little water and begin again. I removed the water with my finger and discovered that the smudgy fingerprint, with a flash of white paper showing through, was just the effect I wanted.

Fig. 66

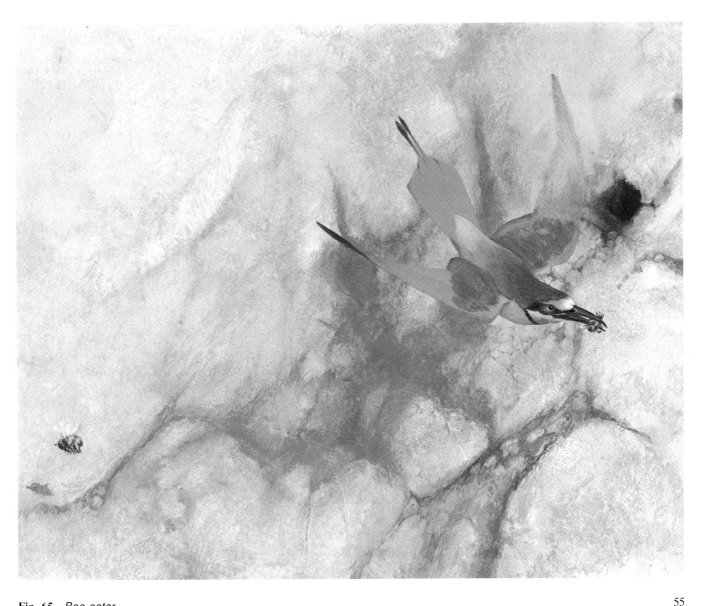

Fig. 65 *Bee-eater*

This painting (**fig. 67**), from Conoco's 1985 calendar, presented me with a particularly unusual problem. As a subject for a wildlife painting, the toad, I must admit, would not spring immediately to mind. Being one of the twelve required 'hunter and hunted' subjects, however, it was necessary to look closely at the animal and to discover some aspect of it which was aesthetically acceptable. This proved harder than I expected and I was beginning to despair of the piece when one of those 'happy accidents' occurred and the picture was set: I was gardening, and a toad walked slowly into the sunlight from under a clump of dock and posed most professionally at my feet; the play of light on the warty skin and the flecks of orange fire in its eyes turned the creature into a thing of jade and amber, quite perfect! I had already assembled details of toads from photographs and earlier drawings, so I had only to carry this image in my mind's eye and bring it to the studio.

I started this oil painting by laying Vandyke Brown on the paper with a Dalon 1 inch flat and working shapes into it with a wooden scraper and a rag, all the time keeping the paint fluid, filling in bits which did not work, and holding those which did. The underlying texture of leaf mould and dead twigs achieved in this way has a most convincing form. Then I began to paint in shadows here and there, with a Dalon D.77 No. 5, to 'flesh out' this background, lending depth and creating visual interest. As you look at an overall texture like this, shapes will suddenly reveal themselves to you as leaves or pieces of bark or whatever, and a fleck of shadow and a dot or two to highlight an edge will reinforce these images and make them clear to everyone. Bring out these forms as they occur to you and slowly build up the strength and quality of your backgrounds. Do not let your painting be spread evenly over the picture plane but give the viewer 'high' points to focus on. These will lead the eye over the canvas in leaps and bounds and make the picture an exciting visual experience.

I used this technique here to lead the viewer into the painting and finally to the focal point, the head of the toad. I painted the leaves of the dock next, which were an extension of the background as far as painting technique went. They were, however, raised above the surface of the ground and had to appear so. Use of shadow is invaluable and should always be considered as an integral part of the composition as well as the device which 'fixes' objects in their proper place.

The background thus completed, I started underpainting the subject of the piece – the toad. A dark green (Prussian Blue and Yellow Ochre) was painted over the area of the toad and the edges were softened into the background with the smallest Dalon fan, rendering a silhouette. Into the soft paint I began to dot in the toad's top colour (Yellow Ochre, Titanium White and Terre Verte, to give a pale grey-green) and I used the actual shape and position of these spots of paint to describe the curves and lines of the toad's body. Paint a little, then stand back and study is the rule; slowly build up the detail, the light and shade, the atmosphere of the painting as you go. The time spent achieving an image in paint is what gives it its depth of feeling, so work carefully and build slowly towards the finish of your work.

The eyes – the colour first, the black pupils second, and the highlights last – usually come at the end of the job, yet with this particular painting one crucial stage remained: the bright shaft of light that would cut right through the composition. I left the picture to go off for a day, then began carefully overpainting the strip of bright illumination with bright gold (Titanium White and Chrome Yellow) on a D.77 No. 2. Every surface facing the light source was filled in and the contours were faithfully followed. When the toad was thus overpainted, I lightened the colour with more Titanium White to separate further and enhance this, the focal point of my piece. The worm was dealt with last of all, and it was not difficult to find a model out in the garden.

Finishing a picture is a wonderfully satisfying moment. Drop your (beautifully cleaned) brush into your brush pot and sit back. Try to be another person who looks on the work for the first time and give an honest appraisal. Seeing a steady improvement in your painting is well worthwhile, and each picture finished leads you on to the next; to another chance to do better.

Fig. 67 *The Toad and the Worm*

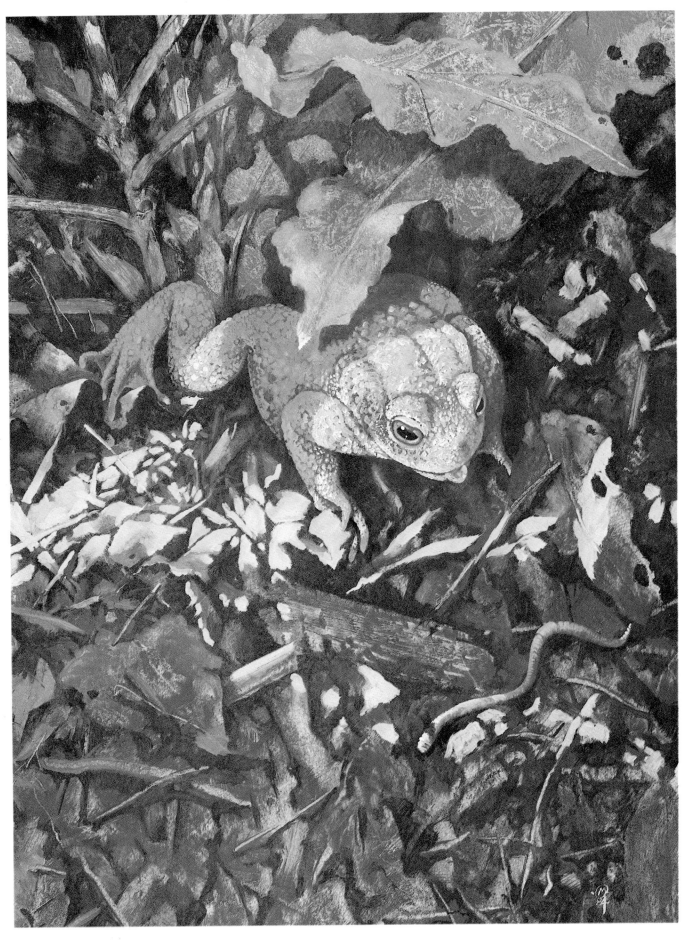

Contrast is a useful device in wildlife painting, where the nature of your subject can be seen in comparison with objects familiar to the viewer. Temperament, scale and texture can be underlined in this way, and in the picture of the brooding robin (**fig. 69**) the rusty metal oil-lamp and the coarse wooden planking give us clear information as to the bird's size and the softness of its plumage. The broom handle and the old fishing rod suggest some of the clutter in which a robin might well feel at home, and so inform us further as to the little bird's nature. The strong shaft of sunlight, just catching the nesting bird, apart from having a strong visual effect of its own, captures that special moment when the hitherto hidden bird is suddenly seen illuminated. The very static nature of the devices around the robin and the fact that it is painted as an integral part of the still life, suggest that, although the bird is aware of being observed, it remains frozen in its situation. It is worth noting here that all substances have a surface character which must be suggested in paint. Here I have tried to paint a living bird covered in feathers; but a porcelain figure of a robin, however realistic, would still be made of porcelain and must therefore appear so in your picture.

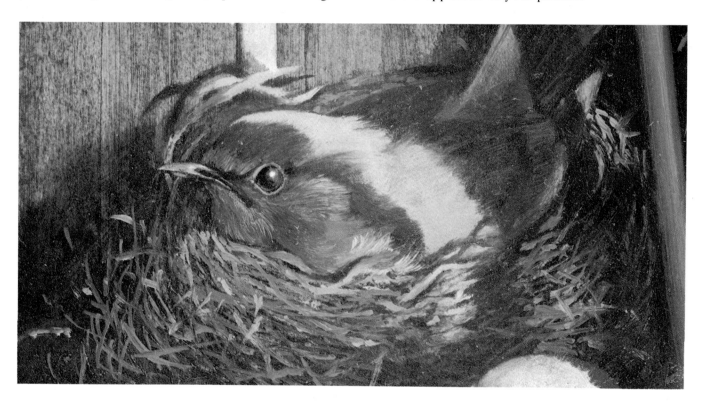

Fig. 68

Fig. 69 *Robin*

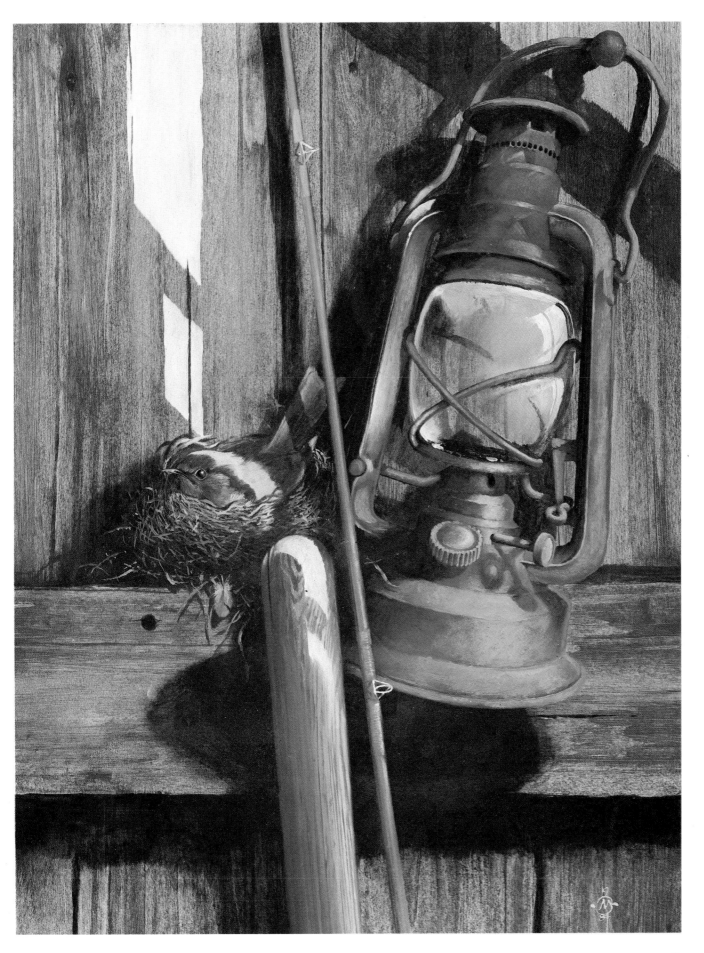

The composition of the hedgehogs (**fig. 70**) was considered after I had seen a baby hedgehog's face and realized, first, that I had not really seen a hedgehog's face in detail before (they are usually tucked out of sight) and, second, what a delightful face it was. I used a setting of smooth roots and autumn leaves to give contrast and scale, and painted three of the creatures to give three slightly differing aspects of the face. The spines were achieved by painting the body shape in Vandyke Brown and then, using a Dalon No. 1 pencil brush, with a single stroke per spine, painting in the buff colour of the prickles into the wet oil paint.

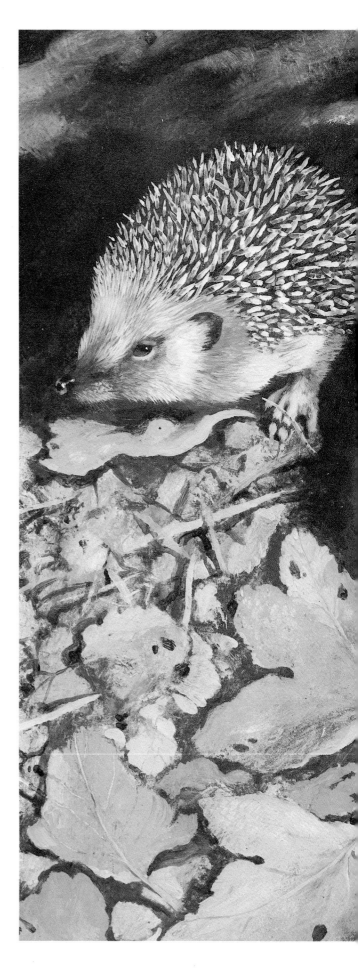

Fig. 70 *Hedgehogs*

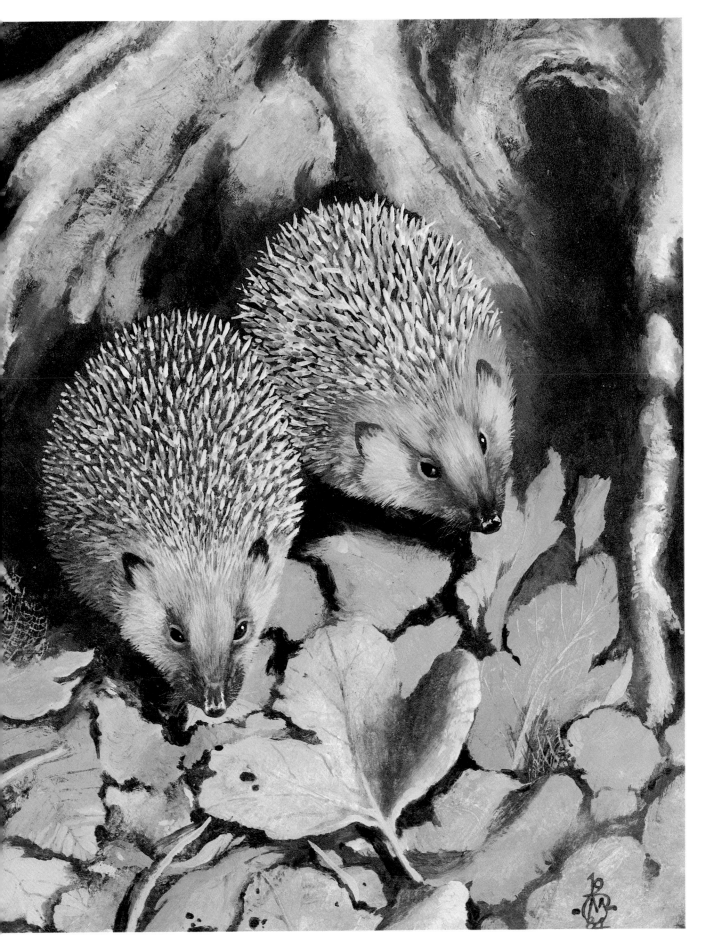

Do not waste time painting every perfect blade of grass unless it has a clear purpose in supporting the point of your picture. If you wish to express the wonderful diversity and brilliance of colour found in the bird world by painting a jay confronting a cock pheasant, you need no more than the merest suggestion of background, letting the riot of colour in the plumage be the sum total of the work. If, on the other hand, you wish to describe the delicacy and jewel-like quality of a tiny mouse, placing your subject against a great scaffolding of dark branches and leaves really emphasizes the exquisiteness of the mouse to your audience and makes a very clear statement of your intent. Here (**fig. 71**), the leaves also serve to hide the weasel and give it a menacing, lurking quality, further describing and contrasting the two subjects of the picture.

Fig. 71 *Weasel and Mouse*

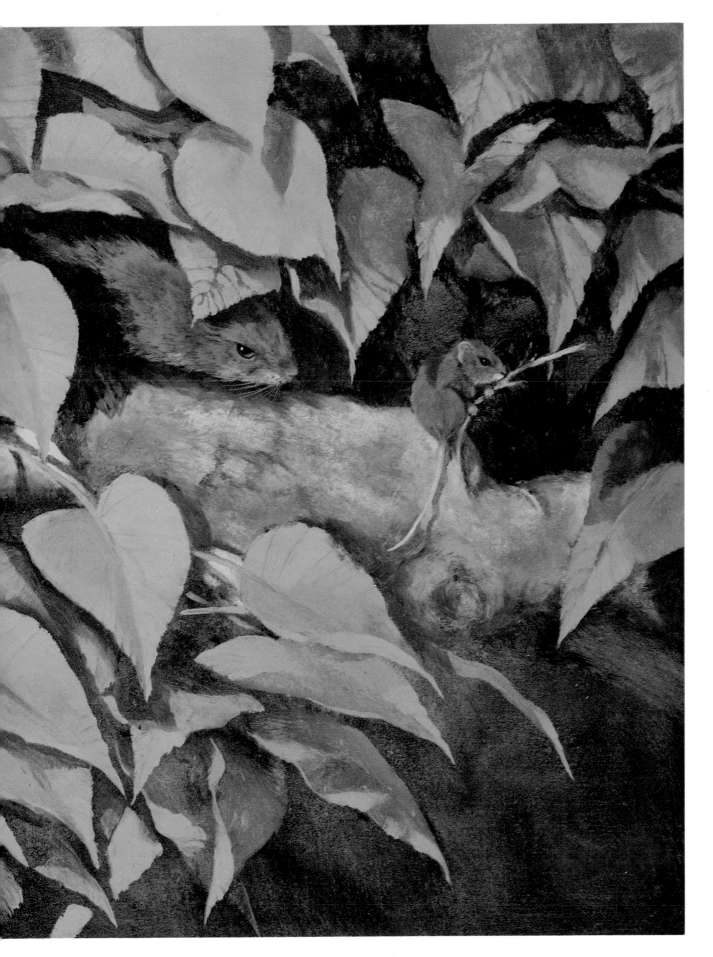

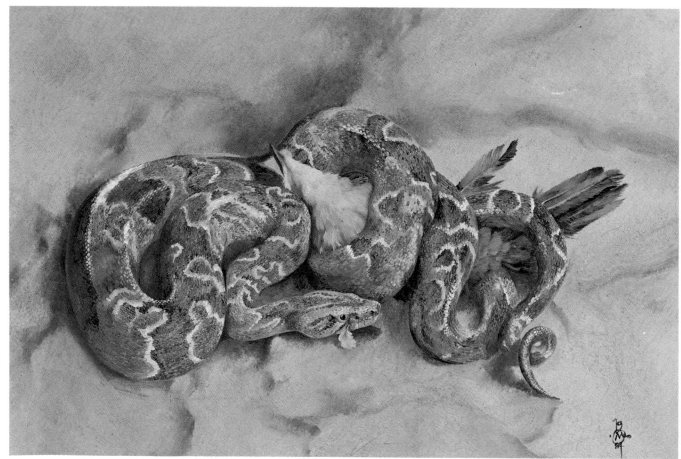

Fig. 72 *Python and Prey*

A python with its prey (**fig. 72**) is a subject with a wealth of opportunities for the painter. The contours of a snake can be formed into an endless variety of shapes. They coil and intertwine, over and under, and are a wonderful visual maze for the viewer. Here I have set the snake on a sand background which suggests by colour the snake's integration with its environment. The pattern of the scales is a work of art in itself. Like a tapestry with each stitch a subtly different colour, the scales describe the beautiful forms of the creature beneath the skin. The head of the serpent is expressionless, alien, and the bird is all but lost beneath the massive power of the coils – just a hint of colour, already overwhelmed.

Using oil paint, I started with Vandyke Brown over the whole picture area and left this for three days to set dry. On this I painted with a Dalon 1 inch flat the sand colour, Yellow Ochre mixed with Zinc White, and stippled this with a Rowney bristle stippler to achieve an even colour, textured as sand. I drew in the outline of the snake with a 2H pencil and began painting in the illuminated areas of the snake's skin with the sand colour lightened with Titanium White. Each scale was achieved by a single stroke of a Dalon D.77 No. 1 brush. The shadows cast on to the sand were created by removing the overpainted sand colour to reveal the dark underpainting. This can be done with a dry brush or a rag, or with anything that will give you a satisfying result. Where the snake disturbed the sand with its coils, I used a stiff brush (a Dalon D.44 is fairly unyielding) to re-create what had happened in life. The result can be uncannily accurate. The forms of the snake were shaded by painting on the same Vandyke Brown as the underpaint and then dotting in the scales in long, lateral lines along the forms of the body. I allowed the paint to blend naturally as I moved my brush from the wet, dark paint to the slightly drier pale colour. By this stage I was using small brushes and working on very small areas. I reinforced light against dark and rough against smooth to keep all the essential forms within the piece readable and clear.

The feathers were painted with a very rough old brush (something like a No. 4) and I deliberately left the brush to give me a ruffled effect. I painted the shadows on the plumage first and then the highlights over the top. Pure Titanium White highlights to bring the serpent to life and Lamp Black with Vandyke Brown to reinforce the deepest shadow concluded the picture. After a day I softened some parts of the work with a fan. You, too, will get into the habit of looking at what you do with the overall effect in mind, changing and adapting where you feel improvement can be made as you go along.